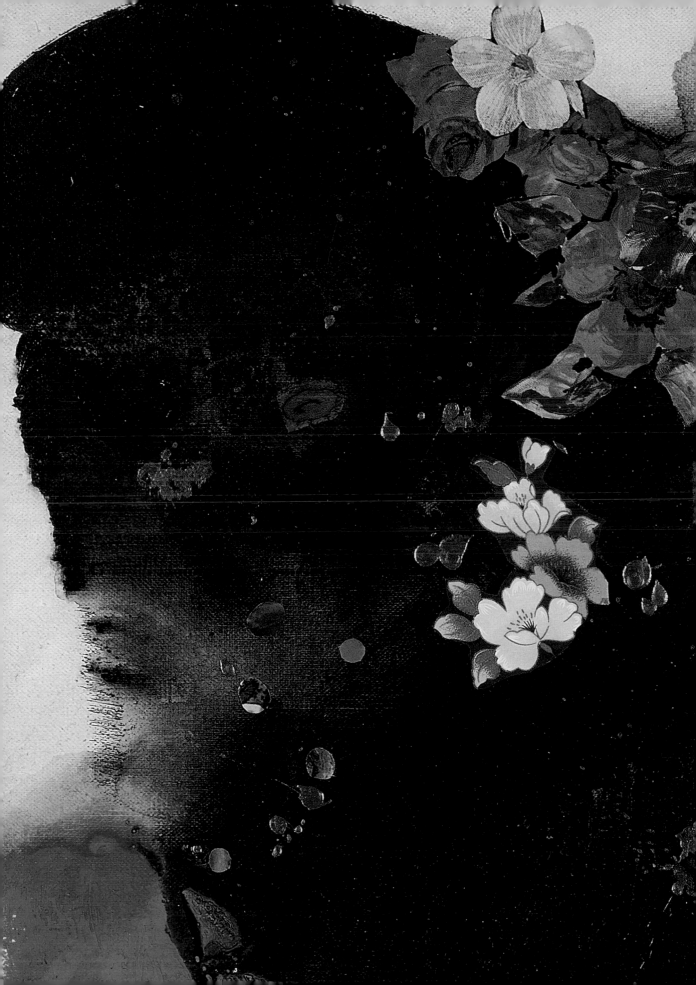

POPULAR IN TAIWAN

陳水扁 前總統

Chen Shui-bian

2023 年春節年假最後一天，阿扁主持的廣播節目《有夢上水》第 109 集，有幸邀請羅榮源、謝碧芬夫婦分享美術人生。

一位是新建築畫派的「畢卡索」，一位是現代女版的「洪通」；一位是小一就逃學，唸 7 年小學，一位是小學沒錢買勞作材料，成績被打丁等；一位是中部第一綠色建築師，一位是台灣普羅藝術交流協會理事長。

節目中特別介紹「逃學前輩」考上台南一中，被國中導師虧說「改邪歸正」，最後成為在大學主授油畫的奇想建築師畫家。國中畢業半工半讀的謝碧芬，則從剪貼藝術創作發跡，老布莊零碼布也是藝術創作好題材。

阿扁也提到羅榮源入畫的「鳥類是台灣生態的未來」，春夏秋冬各具風情的《玉山行旅圖》，從設計「法蒂瑪聖母堂」到《法蒂瑪狂想曲》的畫作，甚至看世足賽也能畫心得，加上最近的創意 P 圖，創意無限的他自稱是「台灣新建築畫派」。

「洪通」如何看「畢卡索」？是「畢卡索」影響「洪通」，還是「洪通」的綠概念藝術比「畢卡索」更風台灣！？

「洪通」比「畢卡索」更風台灣

On the last day of the Lunar Year holidays in 2023, Ah Bian hosted the radio program "It's Most Beautiful to Have a Dream", episode 109, and had the honor of inviting Mr. and Mrs. Luo Jung-Yuan and Ms. Hsieh Pi-Fen to share their life.

One is the "Picasso" of the New Architectural Painting School, while the other is the modern female version of "Hung Tung." One skipped school in the first grade and completed the elementary school for seven years, while the other couldn't afford materials for art class in elementary school and was awarded a grade of "D". One is the first green architect in central Taiwan, while the other is the chairwoman of the Taiwan Proletarious Art Exchange Association.

The program also highlighted the story of the "truant senior" who was admitted to Tainan First Senior High School and was criticized by his junior high school teacher for "reforming", but eventually became a whimsical architect-painter who teaches oil painting at the university. Hsieh Pi-Fen, who graduated from junior high school while working part-time, made a name for herself in the art world with her collage artwork, and even remnant from old fabrics store was also a good subject of art creation.

Ah Bian also mentioned the Luo Jung -Yuan's artworks "Birds are the future of Taiwan's ecology", and the four-season landscape painting of "Journey to the Yushan", which has its own style in spring, summer, autumn and winter. From the design of "Our Lady of Fatima Church" to the painting of "Fatima Rhapsody", he can even draw insights from watching the World Cup, and with his recent creative photo editing, he calls himself the "New Architecture School in Taiwan".

How does Hung Tung view Picasso? Did Picasso influence Hung Tung, or is Hong Tong's green conceptual art even more representative of Taiwan than Picasso?

USE by USELESS

羅榮源 建築師

Lo Jung-Yuan

　　曾經在大學教書三十年的我，有一半時間在教授美術相關課程，尤其是只有一個學期的選修課。我必須去思考如何讓學生有最多的收穫及學習效果，因此在課堂上試著教「剪貼」，幾年下來，反應很不錯。

　　我把教授剪貼的課程，也在自己的太太謝碧芬身上實驗，一開始動手，馬上就交出令人驚艷的作品。她先從身旁用剩下「無用」的卡典西德做為媒材，然後又學習「自動性繪畫」結合布料創作，近年更搭配歐普藝術，使作品更有空間層次感。

　　我很願意將她介紹給所有人，藉由她的作品，可以讓大家感受到「YES！YOU CAN DO！」並深入體會一位從大家認為「無用」回收材料開始，轉化成具有「大用的心靈雞湯」的藝術工作者。

　　多年來，我陪著她到偏遠小學義務教學，就是希望將正向力量引進生活中，也期許這本書的出版，能夠給常常千篇一律的兒童畫，注入另一種媒材創作的方式與方法。

Husband's
Words

無用之用

Having taught in universities for 30 years, I have spent half my time teaching courses related to fine arts, especially elective courses with only one semester. I had to think about how to get the most out of my students and how they could learn, so I tried to teach "clip and paste" in my classes and the response was very good over the years.

I took the class I taught on "clip and paste" trying out on my wife, Hsieh Pi-Fen. As soon as she started to work, she immediately produced amazing works. She first used the leftover "useless" card sheet as her medium, then learned "automatic painting" combined with fabric creation. In recent years, she has been working with Op Art to make her works more spatial and layered.

I would love to introduce her to everyone, and through her work, people CAN feel " YES ! YOU CAN DO !" , and deep understand an artist who started with recycled materials that were considered "useless" and turned them into "useful chicken soup for the soul".

Over the years, I have accompanied her to remote elementary schools for voluntary teaching, hoping to introduce positive forces into life. I also hope that the publication of this book can inject another way and method of media creation into the children's painting, which is often monotonous.

RATIONALITY & SENSIBILITY

紀向 藝術評論家

Chi Hsiang

　　謝碧芬作品結合點描技法，表現於因時空交錯的引力空間，讓欣賞者近觀「三原色」，遠觀則「飄浮意境」，有視覺宏觀、詩情畫意之趣。每一幅畫彷彿都會呼吸，有其結構與故事性，「創意、創新」正是畫中靈魂，散發出正能量的爆發力。

　　單就藝術創作進行方向而言，她不離女性纖細的思維，更以普普藝術觀念，極盡利用身邊素材，創造出無數現代思維色感與結構，這是一種屬於謝碧芬，一種屬於台灣後普普藝術，綠色主義概念的拼貼藝術。

　　如此謝碧芬，不僅跨越綠色環保工作者的身分，也更清楚表現出作為女性藝術工作者，一種內在潛意識，存在的莫大藝術創作的力量。不僅是一位用拼貼完成綠色主義概念的藝術尖兵，也是在堅韌女性在創作表現上，一個絕對理性又兼備感性的藝術家。

Fore

Commet
理性與感性

The works of Hsieh Pi-Fen are combined with pointillism technique, which is expressed in the intertwined gravitational space of time and space, allowing the viewer to see the "three primary colors" up close and the "floating artistic mood" from afar, which is visually magnificent and poetic. Each painting seems to breathe and has its own structure and story, "Creativity and innovation" is the soul of the painting, which exudes the explosive power of positive energy.

In terms of the direction of her artistic creation, she has never left the delicate thinking of women, and has used the concept of pop art to create countless modern ideas of color and structure by making the best use of the materials around her. This is a kind of collage art that belongs to Hsieh Pi-Fen, to Taiwan's post-pop art, and to the concept of greenism.

In this way, Hsieh Pi-Fen not only transcends her identity as a green worker, but also clearly shows the great power of artistic creation that exists in her inner subconscious as a female artist. She is not only an artistic spearhead who completes the concept of greenism with collages, but also an artist who is rational and emotional in the creative expression of tough women.

TABLE ^{OF} CONTENTS 1

推 薦 序

洪通比畢卡索更風台灣 / 陳水扁 02
POPULAR IN TAIWAN

無用之用 / 羅榮源 04
USE BY USELESS

理性與感性 / 紀向 06
RATIONALITY & SENSIBILITY

故 事

01 平凡家庭主婦 16
ORDINARY HOUSEWIFE

02 創作第一步 20
THE FIRST STEP

03 隨興創意拼貼 24
CONFIDENCE TO BE MORE CREATIVE

04 好簡單，我也會 28
SO EASY, I CAN DO IT

05 一起動手作 32
LET'S DO IT TOGETHER

06 亦師亦友的先生 36
A MENTOR AND A FRIEND

07 增加想像力 40
INCREASES IMAGINATIVE TRAINING

08 綠色再生理念 44
THE CONCEPT OF GREEN REGENERATION

09 不同意境的佳作 48
DIFFERENT MOODS OF MASTERPIECES

10 傳家之寶 52
A FAMILY HEIRLOOM

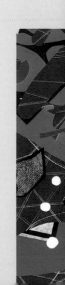

TABLE ^{OF} CONTENTS $\boxed{2}$

作 品 集

念故鄉
REMEMBER THE HOMETOWN
56

新月八卦山
NEW MOON IN BAGUA MOUNTAIN
58

看見未來
SEE THE FUTURE
60

歡天喜地
OVERJOYED
62

豐收
HARVEST
64

一鹿長紅
PROSPEROUS ALL THE WAY
66

綠意盎然
GREENERY
68

虛懷若谷　　　　　　　　70
OPEN-MINDED

舞孃　　　　　　　　　　72
DANCING GIRL

波光粼粼　　　　　　　　74
SHIMMERING WAVES

暮　　　　　　　　　　　76
TWILIGHT

花開富貴相合意　　　　　78
BLOSSOM AND PROSPERITY

花道佈局　　　　　　　　80
FLOWER ARRANGEMENT

春暖花開　　　　　　　　82
SPRING BLOSSOM

戀戀百水　　　　　　　　84
LOVE HUNDERTWASSER

TABLE OF CONTENTS $\boxed{3}$

作品集

明月之星
MOON STAR
86

戀戀故鄉情
LOVE HOMETOWN
88

時尚夢想
FASHION DREAM
90

慶有餘
MORE THAN CELEBRATING
92

二月春風
THE SPRING BREEZES IN FEBRUARY
94

談天說地
TALKING ABOUT EVERYTHING
96

花精靈
FLOWER SPIRIT
98

熱帶雨林
TROPICAL RAINFOREST　　　　　　100

春宴
SPRING FEAST　　　　　　101

宏觀（一）
MACRO（Ⅰ）　　　　　　102

宏觀（二）
MACRO（Ⅱ）　　　　　　103

柿柿甜蜜
SWEET PERSIMMON　　　　　　104

風行天上
WIND IN THE SKY　　　　　　105

八吉祥
EIGHT AUSPICIOUS　　　　　　106

夜曲
NOCTURNE　　　　　　107

TABLE OF CONTENTS 4

作 品 集

明暗交織的人生　　　　　　　　108
A LIFE OF LIGHT AND DARKNESS

寬心自在　　　　　　　　　　　110
FREEDOM OF MIND

相生相熟　　　　　　　　　　　112
ACQUAINTANCE WITH EACH OTHER

酒醉的探戈　　　　　　　　　　113
DRUNKEN TANGO

大船入港　　　　　　　　　　　114
A BIG SHIP ENTERS THE PORT

歡顏　　　　　　　　　　　　　116
HAPPY FACE

戀戀土耳其　　　　　　　　　　117
LOVE TÜRKIYE

玉　山　行　旅　圖　系　列

春　　　　　　　　　　　　　　118
SPRING / Series of Journey to the Yushan

夏　　　　　　　　　　　　　　120
SUMMER / Series of Journey to the Yushan

秋　　　　　　　　　　　　　　122
AUTUMN / Series of Journey to the Yushan

冬　　　　　　　　　　　　　　124
WINTER / Series of Journey to the Yushan

發　　　　　　　　　　　　　　126
FLOURISHING / Series of Journey to the Yushan

STORY ^{OF} THE AUTHOR

謝 碧 芬

Hsieh Pi-Fen

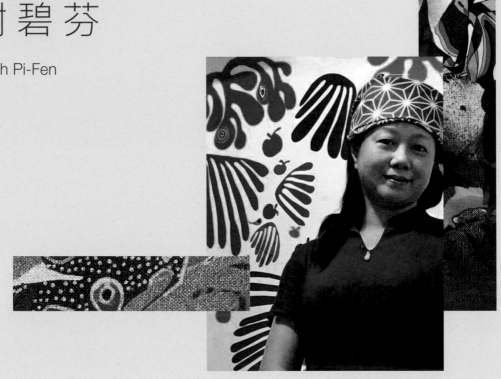

1

平凡家庭主婦

原本我只是一個平凡的家庭主婦，因先生羅榮源的鼓勵與指導，無意間就像落入凡間的精靈，投入藝術創作行列，轉而讓人生更多采多姿。

我在台南出生長大，就讀北區立人國小、民德國中，想當年受升學主義影響，學校美術課並不受重視。除了國小、國中的美術課，我沒有特別學習繪畫的機會，不過作業曾多次被老師稱讚，並張貼在教室外面走廊成績板。

國中畢業，半工半讀，白天在牙醫診所擔任助理，晚上到台南一中夜間部上課，每天生活在忙碌中。位於診所附近的

台南社會教育館，定期有藝術作品展覽，我偶而會利用中午休息時間去看展，但對藝術仍懵懵懂懂。

結婚後定居台中，我仍穿梭台南、台中兩地，繼續完成商專學程，同時也圓了對婆婆的承諾。先生是建築師，全力投入事業，我則幫襯事務所行政，並忙著照顧兩個子女，幾乎沒有自己時間。

近二十多年來，先生有點不務正業，一心夢想成為專業畫家，我也陪他陸續走過十幾個國家，觀摩各大美術館、博物館，接受藝術的洗禮。

我們曾到維也納參觀奧地利藝術家百水先生設計的國宅，體會到平面作品也可以在建築物上表現，構圖元素包括格林童話、城堡等，色彩繽紛，變成世界知名景點，印象尤其深刻。

1 ORDINARY HOUSEWIFE

I used to be just an ordinary housewife, thanks to the encouragement and guidance of my husband, Mr. Lo Jung-Yuan, inadvertently, like an elf falling into the mortal world, throwing myself into the ranks of artistic creation, instead, making life more colorful.

I was born and brought up in Tainan, and I studied in Liren Elementary School and Minde Junior High School in the North District. In those days, due to the influence of the doctrine of "promotion to higher education", art classes were not given much importance in school. I did not have the opportunity to learn painting, except for the art classes in elementary and junior high schools, but I was praised many times by my teachers for my assignments, which were posted on the grade board in the corridor outside the classroom.

After graduating from junior high school, I worked and studied part-time, as an assistant in a dental clinic during the day and taking classes in the evening department of at Tainan First Senior High School, living a busy life every day. At National Tainan Living Art Center near the clinic, there were regular exhibitions of artworks, which I would occasionally visit during my lunch break, but I still didn't know much about art.

After getting married and settling down in Taichung, I still shuttled between Tainan and Taichung to continue my studies in business school and fulfill my commitment to my mother-in-law. My husband, an architect, was devoted to his career, while I was working as an administrator of the architect office and taking care of my two children, leaving me little time to myself.

For the past 20 years or so, my husband has been a bit careless of his business, dreaming of becoming a professional painter, and I have accompanied him on his travels to more than a dozen countries, visiting major art galleries and museums to receive the baptism of art.

We visited the Hundertwasser Haus by Austrian artist Hundertwasser in Vienna and were particularly impressed to learn that graphic works can also be represented on buildings, with colorful compositions such as Grimm's fairy tales and castles, which have become world-famous attractions.

2

創作第一步

在子女都唸大學之後，我常一個人在家，雖然定期參與社團或公益活動，卻也面臨中年空窗期，有點茫然，彷彿失去目標。

2007 年 11 月某日，和獅子會會友們到嘉義參觀交趾陶館，每個人在沒有心理準備下，都收到一只素坯陶盤，各有 15 分鐘即興時間，用毛筆沾上素坯顏料，畫上自選題材。我當下用了一筆畫技法，一筆畫到底，再點上眼睛，當作魚兒正吃著餌。

作品送進窯燒，七天後送到家裡，先生一看讚賞不已，直呼「孺子可教也」，還特別請人裱框。於是，他開始介紹馬諦斯晚年剪貼畫給我看，也常邀我一起欣賞藝術家紀錄片DVD，或隨意在客廳置放米羅、畢卡索畫冊等，讓我翻閱進修。

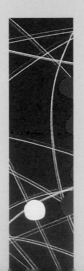

　　由於先生在大學兼課授教「建築設計」與「油畫」課程，有一次，請我幫忙剪 20 個「眼睛」當教材，我利用看電視八點檔時間認真完成。

　　先生發現我手工不錯，隔日竟又預訂 200 個眼睛，害我連續好幾天剪得昏天暗地。後來，這也練就一身功夫，有了純熟剪刀手藝，加上學習欲望，竟從此開啟創作的第一步。

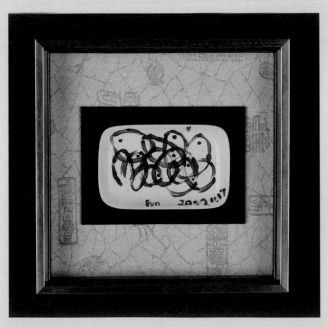

▲ 八吉祥

2 THE FIRST STEP

After my children went to college, I was often alone at home. Although I regularly participated in associations or public welfare activities, I was still facing the middle age gap period, which made me feel a little confused and lost my goal.

One day in November 2007, I visited the Koji Pottery Museum in Chiayi with my Lions Club friends. Each of us was given a biscuit pottery plate and 15 minutes each to paint a subject of our choice with biscuit paint. I used the one-stroke technique, painting the whole thing in one stroke and then dotting the eyes as if the fish were eating the bait.

The artwork was sent to the kiln for firing and arrived at home seven days later. My husband was so impressed that he exclaimed, "you can be taught", and had it framed. Soon afterwards, he introduced me to Matisse's later cut-outs, and

often invited me to watch the artist's documentary DVDs, or he would leave the Miro and Picasso albums in the living room for me to look through for further study.

Since my husband teaches part-time at the university on "Architectural Design" and "Oil Painting", he once asked me to help him cut out 20 "eyes" as teaching materials. I took the time to watch the 8 o'clock program on TV to finish them.

My husband found that I was good at handwork, and the next day he ordered 200 more eyes, which caused me to cut in a daze for several days in a row. Later, I was able to practice my skills, and with the skill of scissors and the desire to learn, I was able to take the first step to create.

3

隨興創意拼貼

先生認為藝術就是反映生活，傳統繪畫需基礎素描及太多材料，讓許多人立即打退堂鼓，建議我一開始，用隨手可得的素材，只貼不畫。例如回收的報紙、雜誌、卡典西德、布料等各種組合，將可替自己找到另類的簡易創作路徑。

我從零開始，在他指導下，初期只是簡單拼貼，沒有特定方向或學習對象，也從不打版，隨興紙的形狀剪貼，一刀剪到底；加上對自我美感的要求，每個圓都很自然，並有各種變化。就像泡麵一樣，每天吃也會膩，因此要加以變化，加點青菜或雞蛋提味。

一想到任何跟圓有關的東西，例如樹的年輪、甜甜圈、糯米餅、好吃的小耳朵，各種圓的變形，都可讓作品更生動活潑。我也運用數學的機率問題，排列不同顏色組合，再透過先生畫龍點睛而有不同面貌，作品都有兩人簽名。

另外，婚前在牙醫診所的十多年工作環境，也讓我培養出觀察的敏銳度，例如牙齒的細微色差，以及牙體型態的雕塑之美。而單純取材自各種印刷品的顏色，也可以表現出一幅幅出色作品，不被具體形狀束縛。一兩年之後，自己漸漸有了信心，更隨興發揮創意。

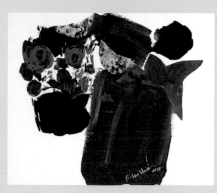

▲ 豐收

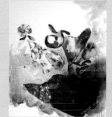

▲ 二月春風

▲ 一鹿長紅

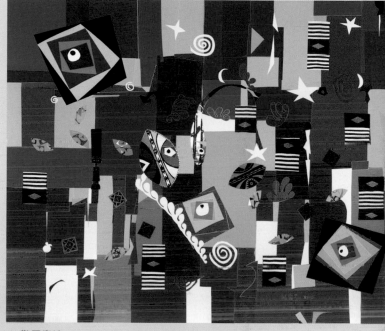

▲ 歡天喜地

　　例如《歡天喜地》是利用回收紙、卡典西德與廣告素材等，《一鹿長紅》、《二月春風》、《柿柿甜蜜》與《豐收》，則是使用到零碼布，都非常具有音樂性與流動感。

　　有趣的是，先前向廣告美術社店家索取剩餘碎紙時，老闆都說免費。不久再去，店家開始收 30 或 40 元；接著又去時，竟改一碼一碼計費了，頓時垃圾變黃金。

3

CONFIDENCE TO BE MORE CREATIVE

My husband believes that art reflects life, and that traditional painting requires basic sketches and too much material, which discourages many people immediately. He advised me to start with materials that were readily available to me and just paste them without painting. For example, by combining recycled newspapers, magazines, cutting sheets, fabric and so on that I can find an alternative and easy way to create my art.

I started from scratch. Under his guidance, I just made simple collages at the beginning, without a specific direction or learning object, and never made a pattern. I cut and pasted the shapes of the paper as I saw fit, cutting in one stroke. With the demand for self-aesthetics, each circle is natural and has various variations. It is like instant noodles, even if you eat it every day, you will get bored of it, so you must change it up by adding some vegetables or eggs to enhance the taste.

Anything that comes to mind that has to do with circles, such as the annual rings of trees, doughnuts, sticky rice cakes, tasty spiral cookies, and all sorts of variations of circles, makes for a lively piece. I have also used the mathematical problem of chance to arrange different color combinations, and my husband

has added the finishing touches to give the piece a different look. The artwork is signed by both of us.

In addition, working in a dental clinic for over ten years before I married, I developed a keen sense of observation, such as the subtle color variation of teeth and the sculptural beauty of tooth forms. The colors taken from various prints alone can also be used to produce a great piece of artwork that is not bound by specific shapes. After a year or two, I gradually gained the confidence to be more creative.

For example, "Joyfully" is made from recycled paper, cardboard and advertising material, while "Prosperous All The Way", "The Spring Breeze in February", "Sweet Persimmon" and "Harvest" use remnant, all of which have a very musical and fluid feel.

The funny thing is that when I asked art supplies store for leftover shredded paper, the owner said it was free. When I went back soon after, they started charging NTD30 or NTD40. The next time I went back, I found out that they had changed to charge by yard, which turned rubbish into gold.

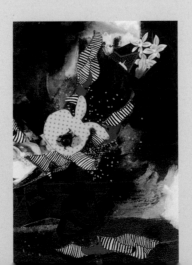

4

好簡單，我也會

　　我經常去看展覽，不管看不看得懂，多欣賞名家畫作，每一幅留在腦海裡的，無形中都是滋養創作的養分。

　　2010年，我在逢甲大學圖書館舉辦第一次個展，正式發表28幅四開小品，獲得相當好評，並受校方邀請展，因此接著嘗試半開到全開的作品。

　　先生和我發起「綠概念藝術」運動，希望結合綠建築精神與當代藝術創作活力，之後，我們常到社區或偏遠山區小學推廣。一些美術老師開始以拼貼做教學媒材，小朋友都非常喜歡，發現原來家裏報紙、雜誌都可當成創作素材，過程中紛紛笑說：「好簡單，我也會！」

　　即興拼貼創作，可以給學童多元文化刺激，有助於開發潛能，提升腦力和鑑賞力。一位自稱是「美術白癡」的老師經過指導後，也創作了一幅很棒作品，無形中竟學會拼貼藝術，連他都被自己感動了。

　　後來，我們協助台中市太平區東汴國小師生舉辦兩場聯展，偏鄉小學本就存在城鄉差距，學生容易缺乏自信，能夠指導師生辦展覽，不僅可以鼓舞學生，也為他們留下值得懷念的記憶。

　　先生認為，藝術在過去已被「專業化、區隔化」，用手畫圖即限制腦袋，學了拼貼，世界將不一樣！所以我們從三歲小孩指導到七、八十歲長者，告訴他們這些方法，他們在過程中愉悅的表情，才是我們想追求的「庶民創作」。

4
SO EASY, I CAN DO IT

I often go to exhibitions, whether I can understand them or not, and admire the paintings of famous artists, as each painting that stays in my mind is invariably a source of nourishment for my creativity.

In 2010, I held my first solo exhibition at the Feng Chia University Library, where I officially presented 28 quarto-size works. The exhibition was well received, and I was invited by the university to exhibit my work, so I continued to experiment with portfolio-size to a standard-size work.

My husband and I started the "Green Concept Art" movement, hoping to combine the spirit of green architecture with the vitality of contemporary art creation. Since then, we have often visited elementary schools in the community or remote mountain areas to promote the movement. Some art teachers started to use collage as a teaching medium, and the children really liked it. They found that newspapers and magazines at home could be used as materials for their artwork, and they laughed during the process, saying, "It's so easy, I can do it too!"

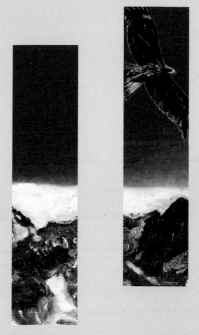

Improvisational collage creation can provide multicultural stimulation for children and help develop their potential, brain power and appreciation. A teacher who claimed to be an "art nerd" was able to create a great piece of artwork after the tutorial. Learning the art of collage in no time at all, even he was touched by himself.

Later, we assisted the teachers and students of Dongbian Elementary School in Taichung's Taiping District to organize two joint exhibitions. As rural-urban disparity is inherent in rural primary schools, students tend to lack self-confidence and being able to guide teachers and students to organize exhibitions not only inspires students but also leaves them with memorable memories.

My husband believes that art has been "specialized and differentiated" in the past. Drawing with your hands means limiting your brain, learning to collage makes the world a different place! That's why we have been instructing children from the age of three to the age of seventy or eighty, showing them how to do it, and the expressions of joy on their faces during the process are what we want to pursue in our "common peoples creative work".

5

一起動手作

　　我家有兩個人以前上美術課，曾得過「丁等」成績。一位是我，小時候因沒買學校統購的美勞材料，交不出作業；我兒子則是因為作業遲交，也是丁等。

　　兒子是沒話說，我則一直把這件事牢牢記住，所以熱衷到學校教學生以及當義工，也是內心的一種補償心理，希望讓學生沒有交不出來的美術作業。

　　小孩子問大人：「為什麼你不會畫畫，難道你忘了嗎？」許多「兒童天才畫家」到最後陸續封筆，最重要原因是太多的「是非觀念」，阻礙了創造力。

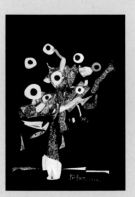
▲ 花訊

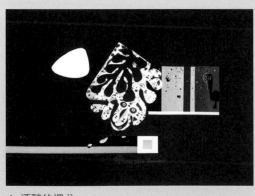
▲ 酒醉的探戈

▼ 相生相熟

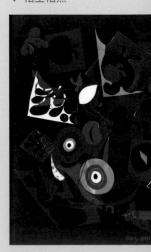

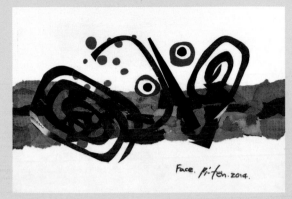

▲ 歡顏

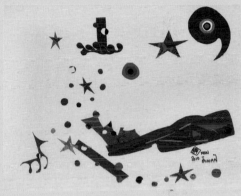

▲ 大船入港

　　所以我們授課時，在一堆碎報紙中，會請學員們閉上眼睛，任手在媒材中游動。背後目的是創作應該自由自在，學習兒童沒有過多的是非觀念。

　　在創作的領域，我們需要的是培養問「問題」的學生，而不是擅長尋找標準答案的學霸。（第一名又怎樣！）每個人只要放下心防，願意動手來創作，就會有自己的作品。

5

LET'S DO IT TOGETHER

There are two members of my family who used to get "D" grades in their art classes. One of them was me, who did not buy the schools art materials when I was a child and could not hand in my work. My son also got a "D" grade because he was late in handing in his homework.

My son has nothing to say about it, but I have always remembered it, so I am keen to teach and volunteer at the school as a kind of compensation, hoping that no student will fail to hand in their artwork.

Children ask adults: "Why can't you draw? Have you forgotten?" The most important reason why so many "child geniuses" end up with no more painters is that there are too many "notions of right and wrong" that hinder creativity.

This is why we ask our students to close their eyes and let their hands wander through the media in a pile of scraps of newspaper during the class. The idea behind this is that creativity should be free, and that children should learn not to have too many ideas of right and wrong.

In the field of creativity, we need students who ask "questions", not straight-A students who are good at finding standard answers (so what?). If you let go of your guard and are willing to put your hands to work, you will be able to create your own work.

6

亦師亦友的先生

　　有一年，先生和我分別申請台中市大墩文化中心個展甄選，審核結果，我竟然通過，他卻落榜了，害他常自我調侃「才華不如老婆」，其實我知道他是非常開心。

　　先生認為，色彩美、構圖佳，經過拼貼再畫，可構成不同的世界。因此從 2015 年開始，指導我進入第二階段的創作，也就是「又貼又畫」。

　　在藝術創作的歷程中，先生亦師亦友，一路陪伴著我，不斷給我鼓勵。由於他也狂熱投入油畫創作，我長年耳濡目染下，很快學會入門技巧，頻繁使用油畫筆，不過作品仍以貼為主。

▼ 寬心自在

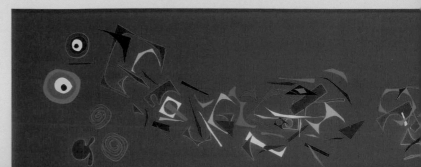

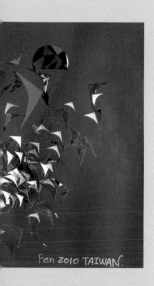

◀ 慶有餘

Fen 2010 TAIWAN.

　　有的創意需用到比較高檔的零碼布，所以我們都到台中市中區成功路的老布莊尋找。日本絲綢布尤其特別貴，還是咬緊牙根買下來，完成作品後，確實感覺有加分。

　　想要如何跳脫框架，建立自己的獨特風格與「語彙」，這也是我開始學習的目標。例如大家熟知的馬諦斯語彙，包括裸女、小丑、美人魚和葉子，奧地利19世紀末最著名畫家克林姆語彙是「螺旋」，都被我引用在自己的作品中。

　　「紙邊魚」則成為我的獨特語彙，將每張紙剪成圓之後的紙邊再利用，透過藝術變幻成海洋中的魚群。每張碎紙片的屑屑，也可化為作品元素之一，放在水裡成為魚，放在天上變小鳥，也可隨興撥弄變成公雞或大鵬鳥。

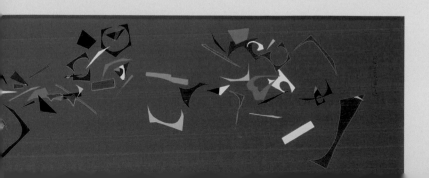

6 A MENTOR AND A FRIEND

One year, my husband and I applied for a solo exhibition selection at the Dadun Cultural Center in Taichung City. As a result of the review, I passed, but he failed. He often teased himself that "the talent is not as good as his wife". In fact, I know he is very happy.

He believes that beautiful colors and good compositions can be collaged and repainted to create different worlds. Therefore, from 2015 onwards, he guided me to the second stage of my work, which is "paste and paint".

My husband was also a mentor and a friend, accompanying me throughout my artistic journey and giving me constant encouragement. As he was also an enthusiastic oil painter, thanks to constant influence, I quickly learned the rudiments and frequently used oil brushes, but my works were still mainly pasted.

Some ideas need to use relatively high-end remnant cloth, so we all went to the old cloth shop on Chenggong Road, Central District, Taichung City

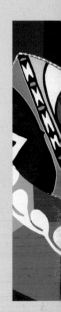

to look for it. Japanese silk fabrics are especially expensive, so I still gritted my teeth and bought them. After finishing the work, I really feel that there is bonus.

It was also my goal to learn how to break out of the box and create my own unique style and "vocabulary". For example, the familiar Matisse vocabulary of nude women, clowns, mermaids and leaves, and Klimt's "spiral", the most famous Austrian painter of the late 19th century, have all been quoted in my own work.

"Paper-edge fish" has become my unique vocabulary. I cut each paper into a round paper edge and reuse It to transform it into a school of fish in the ocean through art. The scraps of each piece of paper can also be turned into one of the elements of the work. When placed in the water, it becomes a fish, when placed in the sky, it becomes a bird, and it can also become a rooster or a roc.

7
增加想像力

在彩色印刷出現之前，報紙都是黑白的。當年唸小學時的美術課，家境好一些的同學，可以有顏色比較多的粉臘筆，現在我們隨便一張報紙、一張宣傳品，都可以找到很多的顏色。

美術創作的工具不一定要用筆畫，找印刷品當媒材，正如先生強調的：「就算只有一點用，我也要告訴全世界！」

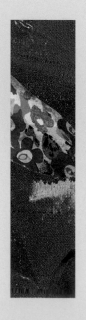

台灣本土真正的諾貝爾獎得主李遠哲，有一位知名畫家父親李澤藩，他來自父親的影響，稍微可以凸顯美術教育的影響在提昇創造力，而不是一定要成為畫家。

學習美術創作的好處，是增加想像力的訓練，所以希望子女們有所成就，拼貼是不可缺少的訓練。

作家用文字當工具，藝術創作者可以用諸多素材表現，可以「只貼不畫」，也可「又貼又畫」，甚至「只畫不貼」，進而「畫貼隨興」。

7

INCREASES IMAGINATIVE TRAINING

Before the advent of color printing, newspapers were black and white. When I was in art class in elementary school, students from better-off families could have pastel crayons with more colors. Now we can find many colors in any newspaper or promotional material.

The tools of artistic creation do not necessarily have to be pens and drawings but prints as a medium. As my husband stressed, "Even if it's only a little bit useful, I want to tell the world!"

Yuan-Tseh Lee, a genuine Taiwanese Nobel Laureate, has a famous father, Lee Tse-Fan. The influence of his father slightly highlights the influence of art education in enhancing creativity rather than necessarily becoming a painter.

The benefit of learning to create art is that it increases imaginative training, so collage is essential if you want your children to achieve something.

While writers use words as a tool, artists can use a wide range of materials to express themselves, either "just paste without painting", "paste and paint", or even "just paint without paste", and then "paint and paste as they wish".

8

綠色再生理念

　　我自己十年磨一剪，拿剪刀進行拼貼創作時，最常出現的語彙，就是靈魂之窗「眼睛」。一張張作品呈現的不是「被看」，而是作品在反過來問欣賞者：「你有真誠對待自己嗎？」

　　在某個教學場合，我事前花四小時剪了 100 個眼睛，現場送給每人 2 個，讓他們隨興貼在自己作品上。眼睛可以提味，互相欣賞，產生共鳴，大家都很開心。一位長者更高興地說，他家牆壁掛的都是孫子的圖畫，如今他自己動手做，也可一起掛上欣賞了。

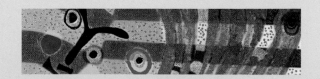

　　我也經常鼓勵初學者，偶發性或即興式創作是最可貴，創作時，想著自己喜歡的事情，打破傳統，更自然、更純真。當自己辛苦完成一幅作品時，內心的喜悦，絕不是金錢買得到的。

　　除了抽象的童趣，外子和我更強調「綠色再生」理念，把美學融入生活當中，如此一步一腳印，也可鼓勵老師指導小朋友們，依照此方式學習，在過程中，也學習「愛地球」的重要性。

8

THE CONCEPT OF GREEN REGENERATION

The term that comes up most often when I take my scissors to a collage that I have been working on for ten years is "eyes", the window to the soul. A piece of work is not about "being seen", but about the work asking the viewer, "Are you being true to yourself?"

In a certain teaching occasion, I spent four hours cutting out hundreds of eyes beforehand, and gave two to each person on the spot, and let them paste them on their own works as they wished. Eyes can enhance the taste, mutual appreciation, empathy, and everyone is happy. One elderly man was even happier when he said that all the pictures on the walls of his house were his grandchildren's. Now he made it himself and can hung it together for appreciation.

I always encourage beginners to create sporadic or improvised works, which are the most valuable. When you create something, think about what you like, break with tradition, and become more natural and innocent. When you finish a piece of artwork, the joy you feel in your heart is not something that money can buy.

In addition to the abstract childlike, my husband and I emphasize the concept of "green regeneration", integrating aesthetics into our lives, so that we can encourage teachers to guide children to learn in this way, and in the process, learn the importance of "loving the earth".

9　不同意境的佳作

　　美國現代藝術家波洛克突破傳統繪畫觀念，用潑灑油漆在畫布上作畫，看過他的紀錄片及作品後，我漸漸學會以潑灑方式做底色。

　　另外，經過自己不斷研發，也用棉棒在畫布上一層層刷塗，用冷色調的線條一次又一次甩在畫布上，都創造出不同意境的佳作。

　　如果是上午進行創作，過程中不能停，因為到了下午，思維又不一樣了。每幅畫至少都需兩週時間才能完成，過程很辛苦，經常要蹲馬步，有時甚至得挑燈夜戰，熬夜到兩三點。

　　有人曾問我一幅畫甩了多少線條？我說就像人的髮量一樣，真的數不清。而且甩的力道，因輕重會有粗細之分，某個色澤須全部完成，才能休息片刻。線條也會因甩的速度快慢，而有不同變化與境界。

▼ 波光粼粼

▼ 戀戀百水
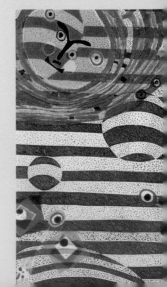

在先生指導進入第三階段「只畫不貼」後，我也學習法國印象派畫家秀拉的點描法，用色點堆砌創作。投入約半年時間，經常看秀拉 YouTube 影片，剛開始點描很難，但至少比甩線簡單，最重要的是自己要勤動手，覺得越來越有趣了，《戀戀百水》是我的代表作之一。

回想以前每年農曆春節，都跟先生開車回台南，沿著台61線經過北門區，他總會說：「這裡曾住一位台灣最有名的素人畫家洪通，曾當過乩童，作品中的鬼魅之氣，是學不來的！」

除了開發新技巧，我更努力加入自己身體語言，以及音樂、律動等元素，讓作品更有內涵；也曾參訪諸多饒富空間趣味的建築，嘗試在平面畫布上表現禪意。

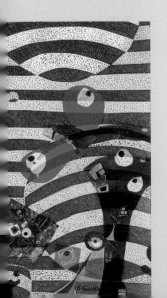

9

DIFFERENT MOODS OF MASTERPIECES

The American modern artist Pollock broke through the traditional concept of painting by splashing paint on the canvas. After watching his documentary and works, I gradually learned to use splashing as the base color.

In addition, through continuous research and development, I have also used cotton swabs to paint the canvas layer by layer, and splashed the lines of cool colors on the canvas again and again, creating different moods of masterpieces.

If I work in the morning, I can't stop during the process because in the afternoon, I think differently. Each painting takes at least two weeks to complete, and the process is very hard, often involving squatting and sometimes staying up until three o'clock at night.

Someone once asked me how many lines were splashed out of a painting. I said it was just like human hair, I couldn't really count it. The force of the splashing varies from light to heavy, and a certain color must be completed before a moment of rest. The lines also have different variations and realms depending on how fast or slow they are splashed.

After my husband guided me to the third stage of "painting without pasting", I also learned the French impressionist Seurat's pointillism, using color dots to build up my work. I invested about half a year and watched Seurat's YouTube videos regularly. At first, it was difficult to do pointillism, but at least it was easier than splashing lines. The most important thing is to work hard on your own, and then will feel more and more interesting. "Love Hundertwasser" is one of my masterpieces.

When I think back to the Lunar New Year every year, I used to drive back to Tainan with my husband and pass by the Beimen District along the West Coast Expressway, he would always say, "Here lived the most famous ordinary person painter in Taiwan, Hong Tong, who had been a medium and the ghostly atmosphere in his works cannot be learned!"

In addition to developing new techniques, I also try to add my own body language and musical rhythms to make my works more meaningful; I have visited many spatially interesting buildings and tried to express Zen on flat canvas.

10
傳家之寶

　　先生和我參加的畫會有諸多前輩畫家，某幾位因為高齡而先行離世。在告別式的場合，我常想：當創作者離開人世時，「創作者的告別式」應該呈現什麼？是留下多少財產呢？還是讓司儀告訴大家：「某某某是知名畫家」？

　　聽說日本嫁女兒的傳統習俗，除了送珠寶、嫁妝，有的還會送一幅畫當傳家之寶。我們如果鼓勵每人動手做，家裡客廳牆上就會有自己的真跡作品，留給子孫是不是更有意義呢？

　　看到「浮世貼」這個名詞，一般會想到是引自日本的「浮世繪」，因為「繪」字扼殺了多少人的創作動機，如果改成為「貼」，會發現用剪貼也可以表現生活趣味。

　　我們上一代經歷過戰爭帶來的苦難，所以幾乎把時間都用來拚經濟，即使有休閒，也不會有「創作」選項。現在台灣社會進入老人化，先生和我積極推廣拼貼藝術，因為看見這樣容易學的方法，可以滋潤每個人心田。

　　大家可以說「我不會畫」，但不會說「我不會貼」。在當下做做剪貼，浮世貼是可以提升心靈的創作，更會帶給每個人的生活小奇蹟。

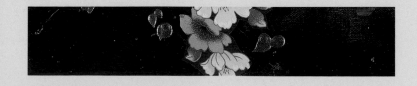

10 A FAMILY HEIRLOOM

There will be many senior painters in the painting associations that my husband and I participated in, and some of them passed away because of their advanced age. On the funeral, I often think: When the creator passes away, what should the "creator's farewell ceremony" present? How much property is left? Or let the master of ceremonies tell everyone: "So-and-so is a famous painter"?

I heard that in the traditional custom of marrying a daughter in Japan, in addition to giving jewelry and dowry, some will also give a painting as a family heirloom. If we encourage everyone to do it by hand, there will be their own authentic works on the wall of the living room at home. Wouldn't it be more meaningful to leave it to future generations?

When you see the term "Ukiyo-paste", you generally think of it as "Ukiyo-e" from Japan, because the word "e (painting)" has killed many people's creative motivation. If you change it to "paste", you will find that using clip and paste can also express the interest of life.

Our previous generation experienced the hardships brought by the war, so almost all our time was spent on the economy, and even if they had leisure time, they would not have the option to "create". Now that Taiwan is becoming an elderly society, my husband and I are actively promoting collage art because we see that such an easy-to-learn method can nourish everyone's heart.

People can say "I can't draw", but they won't say "I can't paste". In the moment of making clip-and-paste, "Ukiyo-paste" is a creation that can enhance the mind and bring small miracles to everyone's life.

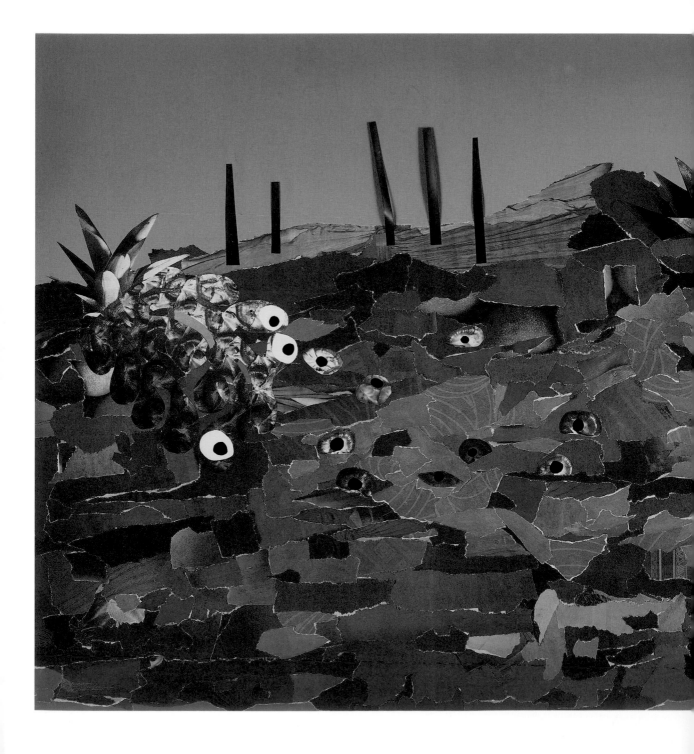

REMEMBER THE HOMETOWN

念故鄉

2014 全開 109.1x78.7cm 複合媒材

我爸爸是彰化芬園人，媽媽出生地在南投。芬園的特色是紅土和鳳梨，我用水果月曆和報紙作底稿，想像果園裡有一些小動物或小朋友，很想偷吃鳳梨呢！

My father is from Fenyuan, Changhua, and my mother was born in Nantou. The specialty of Fenyuan is red soil and pineapples. I used the fruit calendar and newspaper as the backing to imagine that there are some small animals or children in the orchard who would like to steal the pineapples!

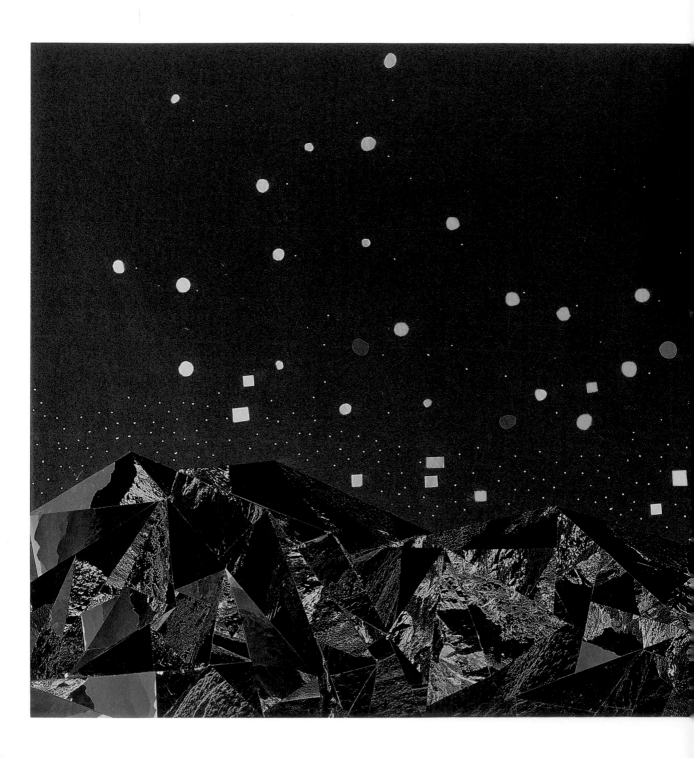

collé

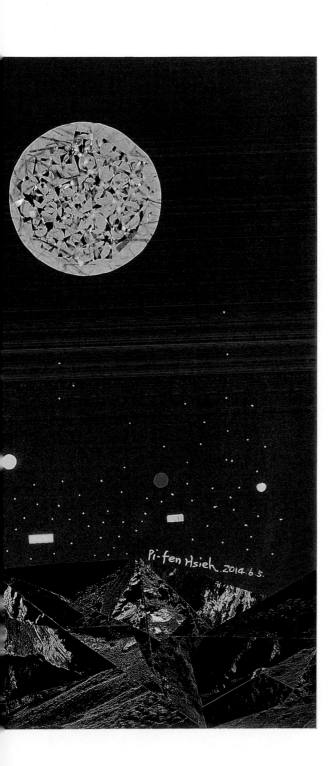

NEW MOON IN
BAGUA MOUNTAIN

新月八卦山

2014 54.5x78.7cm 複合媒材

利用一張雪霸公園月曆以及鑽石切
割概念，我轉而表現彰化八卦山的
樹木、岩石原始樣貌，還有山壁的
光與影。

最細膩的是剪完一顆顆小星星後，
將剩下的一片片碎屑，用細夾子貼
黏在月亮表層。

Using a Shei-Pa National Park calendar
and the concept of diamond cutting, I
turned to express the original appearance
of the trees and rocks of Bagua Mountain
in Changhua, as well as the light and
shadow of the mountain wall.

The most delicate part is that after cutting
out a small star, the remaining pieces of
scraps are stuck to the surface of the
moon with a small clip.

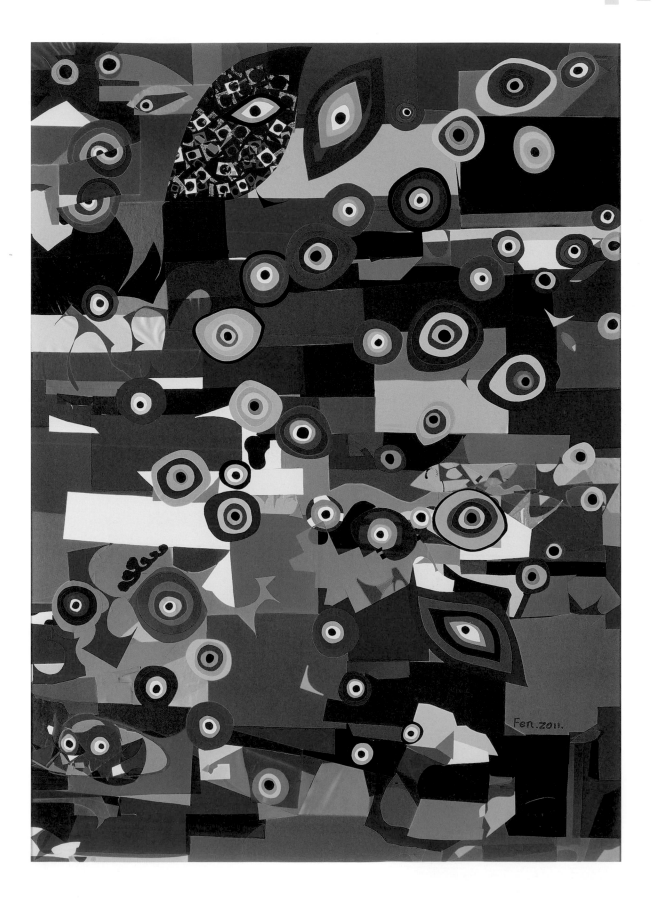

SEE THE FUTURE

看見未來

2011 全開 109.1x78.7cm 複合媒材

畫裡有很多眼睛，也可說圓的變形，每一顆都是我用剪刀剪出來的元素。畫名也可以改稱《萬眾矚目》，因為很熱鬧！

有人說，像棋盤上的圍棋或象棋；也有人說，像一群人愉悅地在跳探戈，一個前進、一個退後，都散發著正能量。

There are a lot of eyes in the painting, or variations of circles, each of which is an element I out out with scissors. The name of the painting can also be changed to "All Eyes" because it is very lively!

 Some say it is like Go or chess on a chessboard; others say it is like a group of people happily dancing tango, one moving forward and one moving backward, all exuding positive energy.

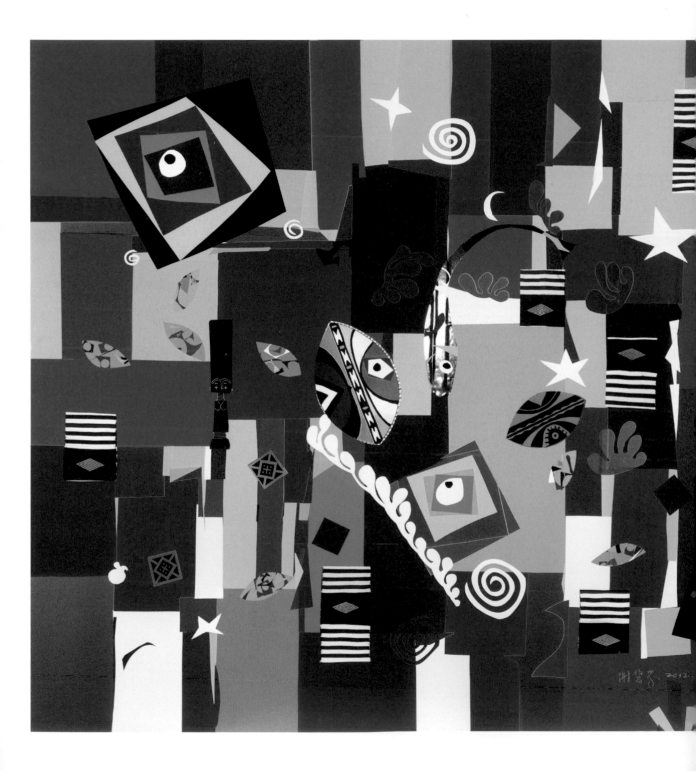

OVERJOYED

歡天喜地

2012 全開 109.1x78.7cm 複合媒材

許多人對抽象畫的第一反應，都是説：「我看不懂！」如果從形狀、色彩、大小、線條、質感和空間，試著找出自己喜歡的顏色，從不同角度欣賞，慢慢會有更多興趣。

使用回收雜誌、報紙、DM 和卡典西德，剪下藝術家的元素，包括克林姆螺旋、八大山人畫作的眼睛特徵、米羅的星星、非洲臉譜圖騰，我也師法馬諦斯風格創作了抽象畫。

Many people's first reaction to abstract painting is to say, "I don't understand it!" If you try to find your favorite colors in terms of shapes, colors, sizes, lines, textures and spaces, and appreciate them from different angles, you will gradually become more interested.

Using recycled magazines, newspapers, DMs and cutting sheets, I cut out elements of the artist, including the Klimt spiral, the eye features of Bada Shanren's paintings, Miro's stars, African face totems, and I also created abstract paintings in the style of Matisse.

tions

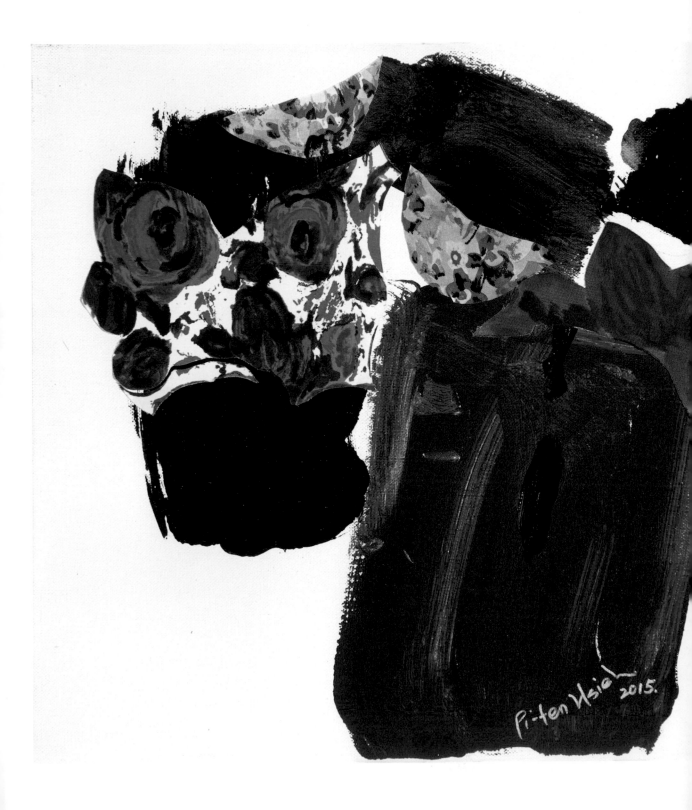

HARVEST

豐 收

2015 53x45.5cm　複合媒材

潑墨完成背景後，手中一塊零碼布剛好有
一大一小玫瑰花，剪成兩個大眼睛，形成
很逗趣畫面。

又宛如桌上可口的水果，令人垂涎欲滴，
有豐收的喜悅。

After the background is completed by splash
ink, a piece of remnant happened to have a
large and a small rose in his hand, which was
cut into two big eyes, forming a very funny
picture. It is like a delicious fruit on the table,
mouth-watering and full of joy of harvest.

tions

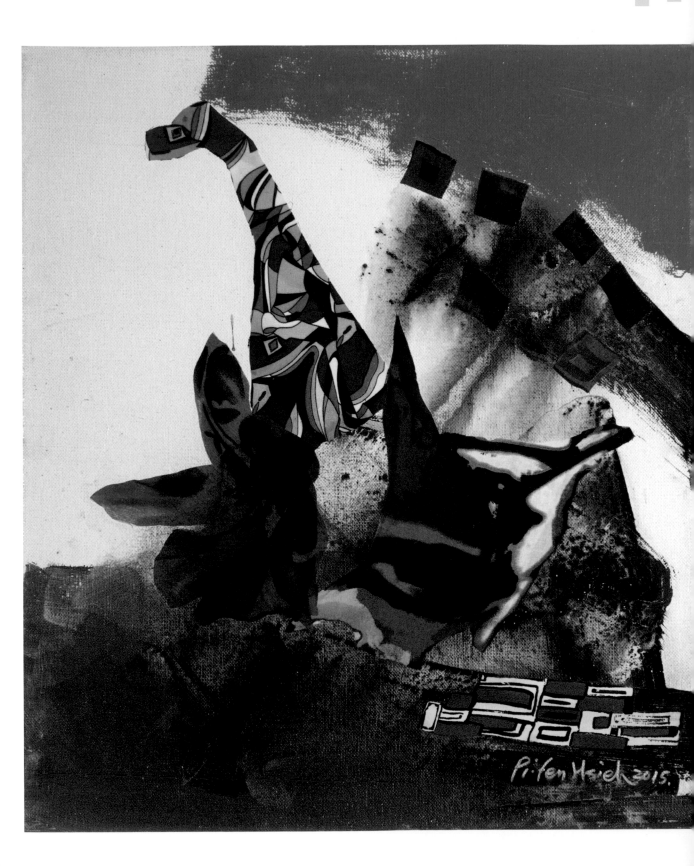

PROSPEROUS ALL THE WAY

一鹿長紅

2015 53x45.5cm 複合媒材

一小塊剩餘的長形零碼布,很像動
物紋路,順手剪成長頸鹿模樣。紫
色是用到綢布,以潤飾旁邊的色調
來提味,右下角則是家中的舊裙子
布料。長頸鹿的眼睛,也是布料其
中的元素。

A small piece of leftover long remnant,
very similar to animal prints was cut into
like a giraffe by hand. The purple color is
made of silk fabric to retouch the color
next to it to enhance the taste, and the
lower right corner is the old skirt cloth
from home. The eyes of the giraffe are
also an element of the fabric.

tions

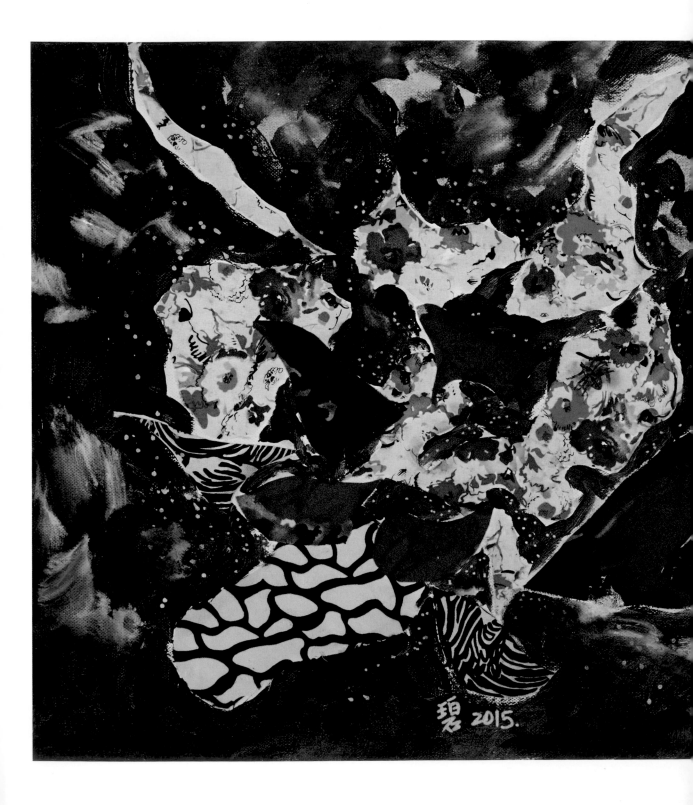

GREENERY

綠意盎然

2015 10F 53x45.5cm 複合媒材

用揮灑滴流方式完成背景，等原料乾了之後，再將零碼布融入畫面，彷彿海面波濤洶湧，又有暗夜的神祕感。

The background is completed by spraying dripping. After the raw material dries, the remnant is then incorporated into the picture, as if the sea is surging, with a mysterious feeling of darkness.

tions

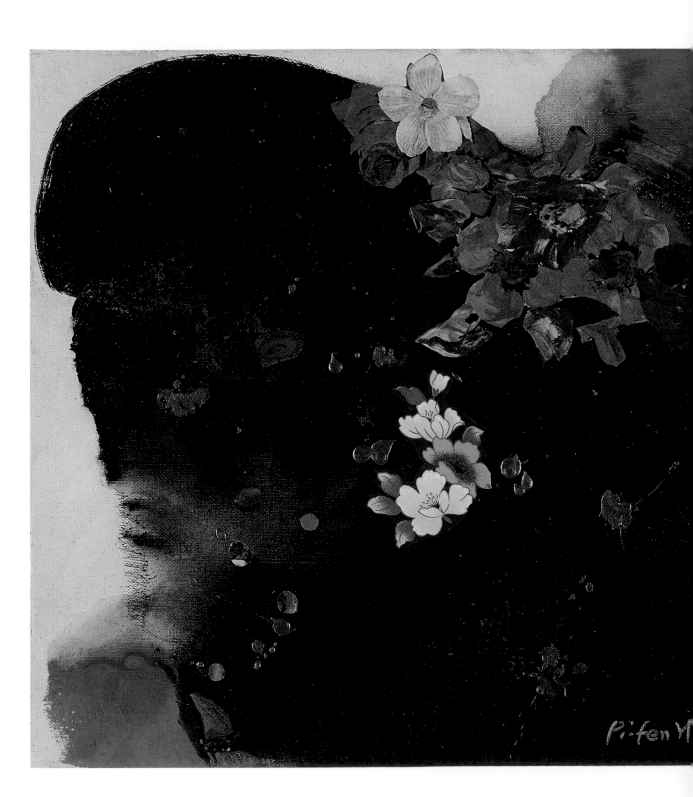

OPEN-MINDED

虛懷若谷

2015　10F 53x45.5cm　複合媒材

潑墨之後，竟意外出現一位柔和的女仕側臉，我用絲綢零碼布當髮飾，再用日本花色對稱。小圓點的花布很像流蘇，加一點點金色顏料，遠觀近看，各有一番風味。

先生說，藝術創作有時候很像打保齡球，不經意的一甩，忽然發現南宋畫家梁楷隔空再現。這也是「自動性繪畫」的樂趣，在花布的搭配下，不經意創作出有潑墨山人風格的作品。

After the ink splash, a soft female profile unexpectedly appeared. I used silk remnant as hair accessories, and Japanese florals for symmetry. The floral cloth with small dots looks like tassels, with a little golden paint added, each has its own flavor when viewed from a distance or near.

My husband said that artistic creation is sometimes like playing bowling. When you flick a ball inadvertently, you suddenly find Liang Kai, a painter of the Southern Song Dynasty, reappearing in the air. This is also the joy of "automatic painting". With the matching of printed cloth, works in the style of Immortal in Splashed Ink are created inadvertently.

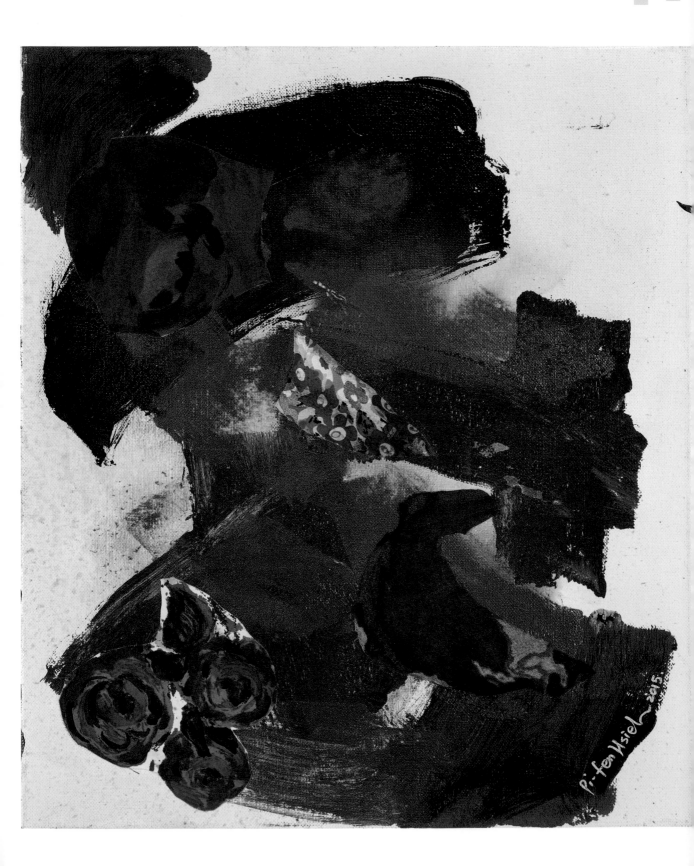

DANCING GIRL

舞 孃

2015　10F 53x45.5cm　複合媒材

台灣藝術家朱銘《太極系列》作品，提
供這幅畫的創作靈感，彷彿這幅畫一直
在動態中。

Taiwanese artist Ju Ming's "Kung Fu" series
provides the inspiration for this painting, as if it
is always in motion.

tions

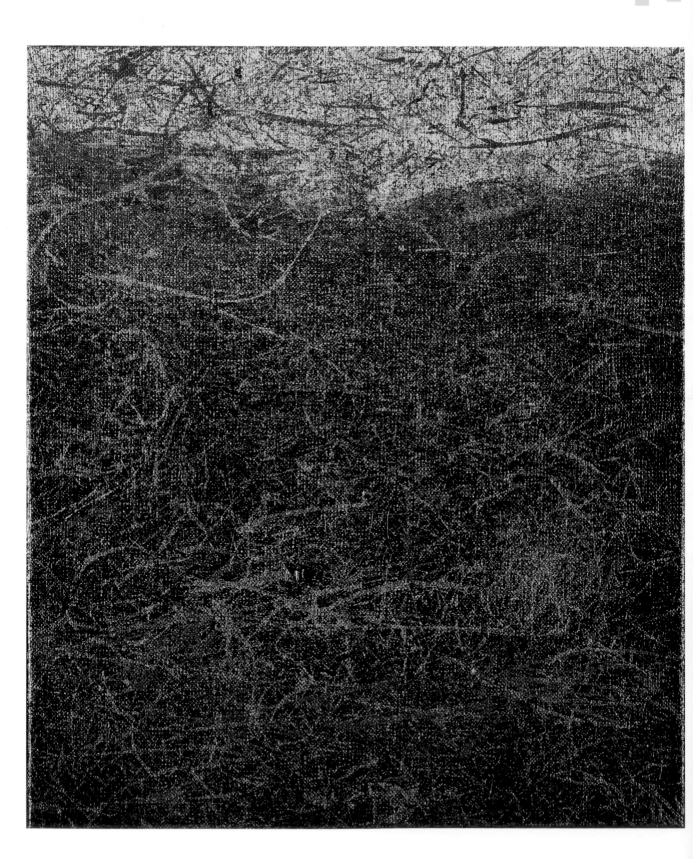

SHIMMERING WAVES

波光粼粼

2019 8F 33x45.5cm　複合媒材

生平第一次到小琉球旅遊時，發現那裡的海洋很奇妙，明明有風又有浪，海面卻四平八穩，讓我整個心情沉澱而愉悅起來。

回到家，首次嘗試墨斗用的棉紗水線創作，將線條一次次的堆疊，宛如配合音樂律動，表達出風平浪靜的意境。

When I traveled to Xiao Liuqiu for the first time in my life, I found that the ocean there was wonderful. Although there were winds and waves, the sea surface was smooth and sable, which made my whole mood calm and happy.

Back home, I tried to create for the first time with the cotton yarn waterline used in chalk line, stacking lines again and again, just like the rhythm of music, to express the artistic conception of calm wind.

TWILIGHT

暮

2019 8F 33x45.5cm　複合媒材

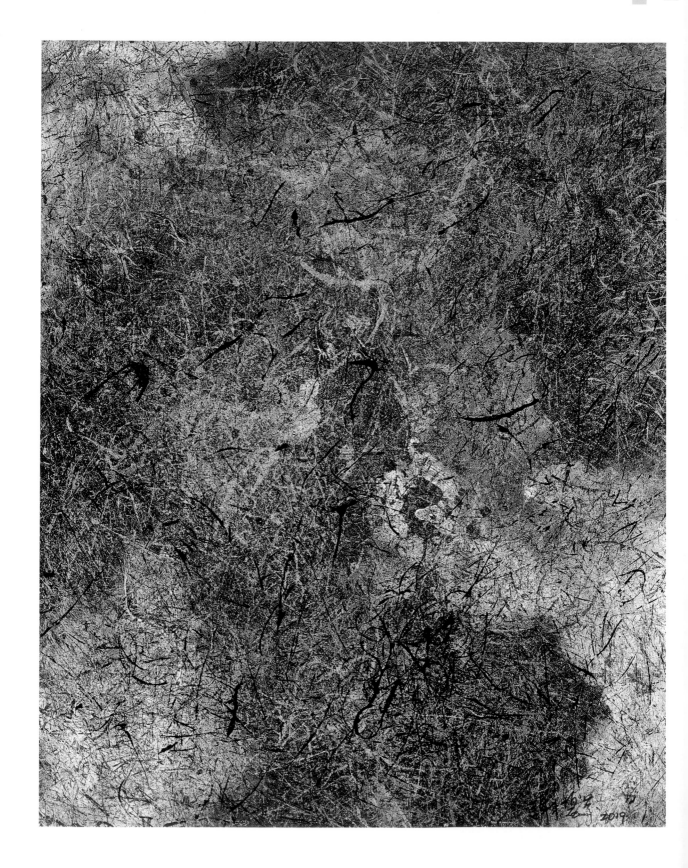

BLOSSOM AND PROSPERITY

花 開 富 貴 相 合 意

2019 30F 91x72.5cm　複合媒材

用 N 層次的線條，在色與線間，放手
一搏，更有景深，好像美麗又熱鬧的
森林，有好幾對情侶在裡面跳舞。

Use N-level lines, between color and line,
give it a go, and have more depth of field,
like a beautiful and lively forest, with several
couples dancing in it.

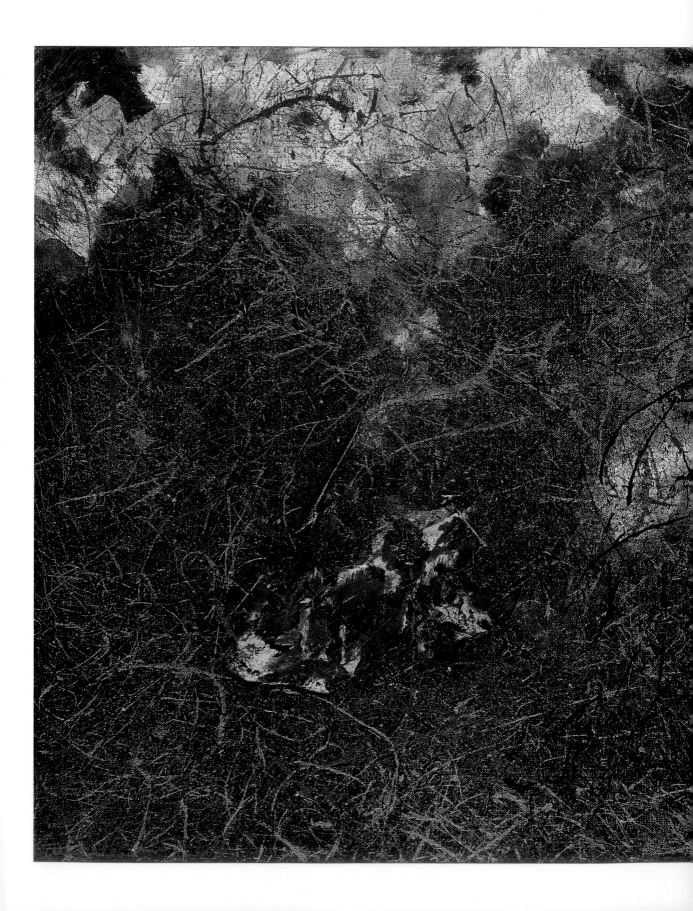

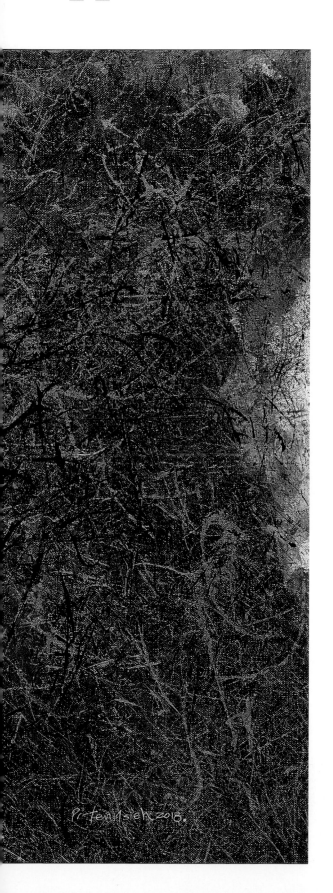

FLOWER ARRANGEMENT

花道佈局

2018　30F 91x72.5cm　複合媒材

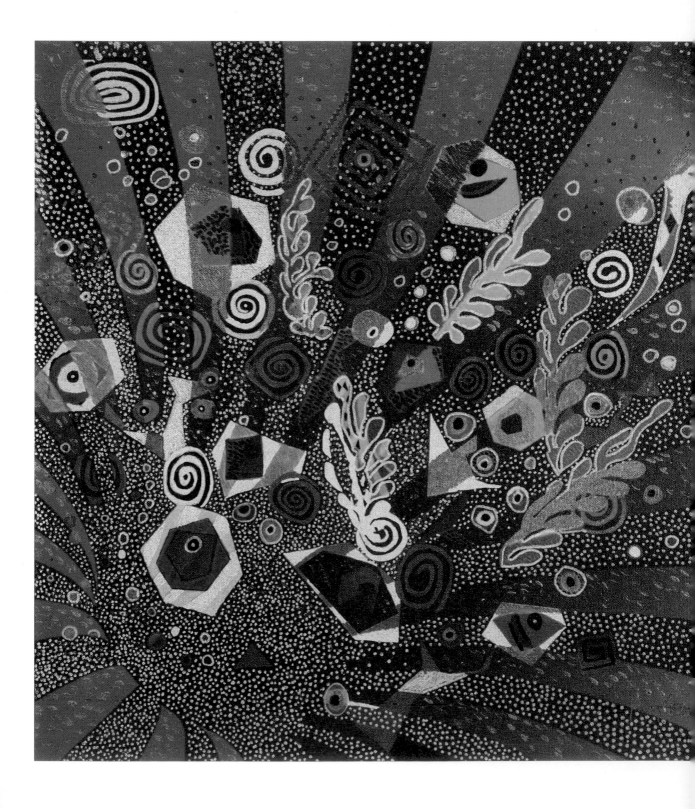

SPRING BLOSSOM

春暖花開

2022 20F 72.5x60.5cm 複合媒材

用自己早年手工拼貼作品，加上最新
數位技術合成，微噴在畫布上構圖。
然後採用點描法，以稀或疏的大點或
小點，透過點線面的不同層次，呈現
宇宙多維空間，更具爆發力，結合了
數位與手工的時尚風格。

I used my early hand-collaged works,
combined with the latest digital technology
to synthesize and micro-sprayed on the
canvas for composition. Then pointillism is
adopted to present the multi-dimensional
space of the universe through different
layers of points, lines and planes with
sparse or large points or small points, which
is more explosive and combines digital and
handmade fashion style.

tions

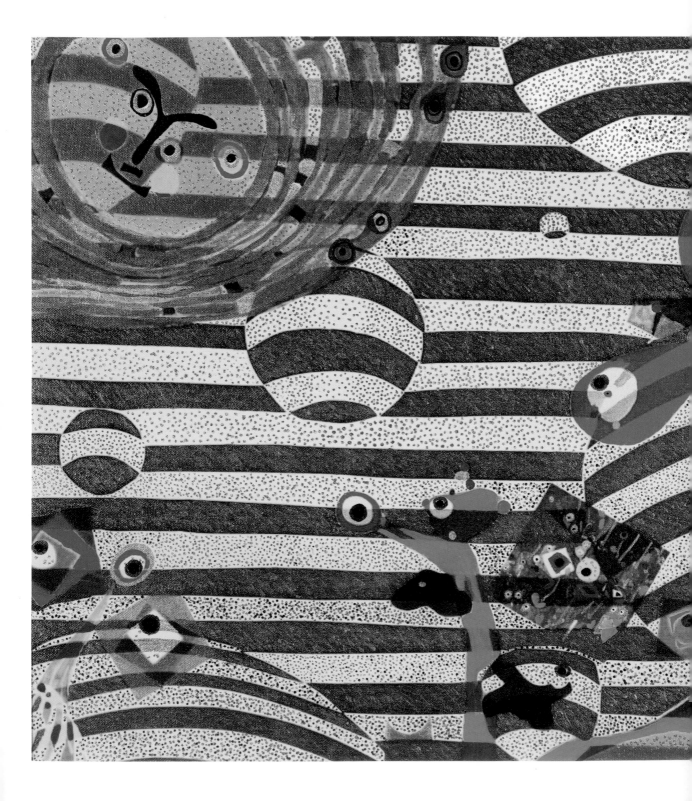

LOVE HUNDERTWASSER

戀 戀 百 水

2021　20F 72.5x60.5cm　複合媒材

台灣俗語說：「三人共五目，日後無長短腳話」，就是事先告知的意思。

左上方臉譜有一字眉的特色，我想表達墨西哥畫家芙烈達率真個性，螺旋狀則象徵她有太陽般氣勢。臉譜四個眼睛，不一定代表兩人，也可想像一個人有三個眼睛。

There Is a Taiwanese saying: "Three people have five eyes, and there will be no words about long and short legs in the future", which means to inform in advance.

The upper left face has the feature of a unibrow, which I want to express the frank personality of Frida Kahlo, a Mexican painter, and the spiral symbolizes her momentum like the sun. Four eyes of face, not necessarily represent two people, but also imagine a person with three eyes.

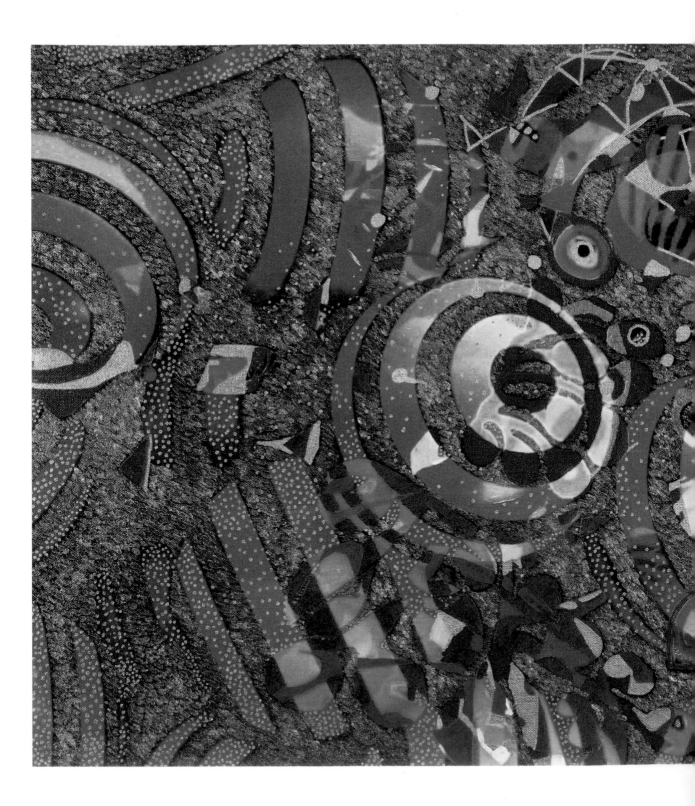

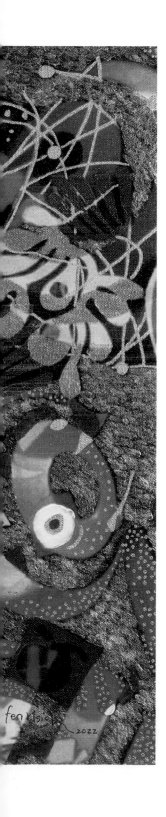

MOON STAR

明月之星

2022 20F 72.5x60.5cm　複合媒材

想起位於阿拉伯杜拜的知名建築物「未來博物館」，我用多維空間概念，將以前作品的元素包括眼睛、圓的變形、一筆畫以及馬諦斯的美人魚，先輸出到畫布，再以複合媒材，加上壓克力原料點描技法，創造出具有時尚感的佳作。

Thinking of the famous building "Museum of the Future" in Dubal, Arabla, I used the concept of multi-dimensional space to export the elements of previous works, including eyes, circle deformation, one-stroke painting and Matisse's mermaid, to the canvas first, and then use mixed media and acrylic materials with the technique of pointillism to create a masterpiece with a sense of modernity.

tions

LOVE HOMETOWN

戀 戀 故 鄉 情

2021 72.5x60.5cm 複合媒材

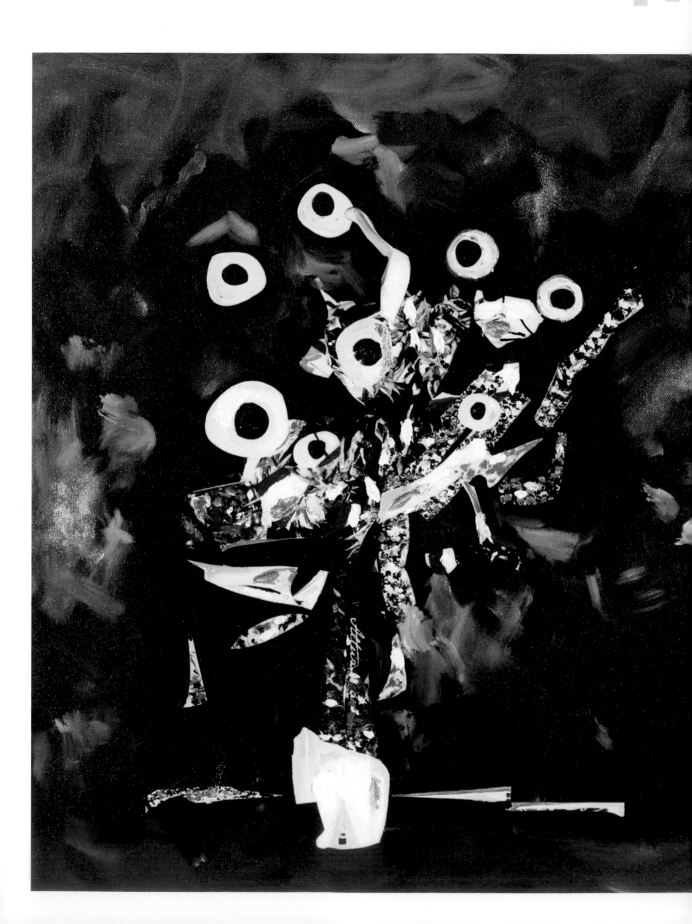

FASHION DREAM

時尚夢想

2021 60x60cm　複合媒材

原畫底稿是「一頁雜誌一幅畫」的剪貼小品，用數位輸出後，再以油畫筆精心完成。背景有很扣人心弦的時尚性，已不像花束，仍像一位揮著水袖的舞者，或宛如五爪魚，想像空間越來越豐富。

The original manuscript is a clipping of "a picture on a page of a magazine", which is printed out digitally and carefully finished with an oil brush.

The background has a very exciting fashion, no longer like a bouquet, but like a dancer waving a water sleeve, or like a five-claw fish. The imagination space is increasingly rich.

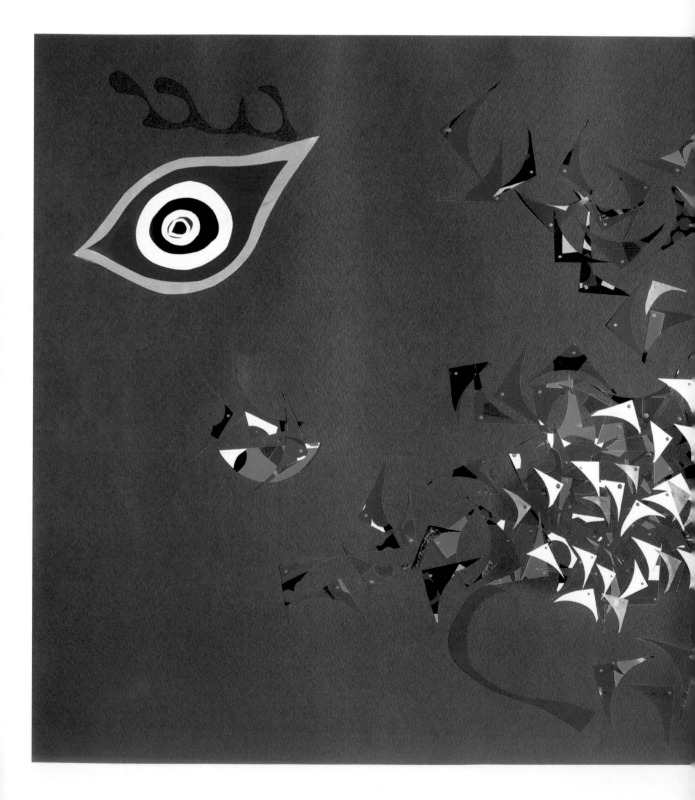

en 2010 TAIWAN.

MORE THAN CELEBRATING

慶 有 餘

2010 四開 54.5x39.3cm 複合媒材

這是我蒐集很多剪了圓型之後，留有四個邊角的卡典西德回收碎紙創作。

那一年，剛好到海洋生物博物館參觀，從展示窗發現兩個很大的魚群，從相遇、問訊到彼此穿越而過的和諧畫面。

靈機一動，我把各種顏色碎紙當成不同魚群，然後隨興撒下，用手撥一撥，再撒第二波、第三波。經過多次堆疊，結果竟讓色彩層次分明，更逗趣自然。

This is a creation of recycled shredded paper from cutting sheets that I have collected a lot and cut out a round shape, leaving four corners.

That year, I happened to visit the National Museum of Marine Biology and Aquarium, and I found two large schools of fish from the display window, from meeting and greeting each other to crossing each other in a harmonious scene.

In a moment of inspiration, I took the shredded paper of various colors as different schools of fish, and then sprinkled them as I liked, flicking them with my hand, and then sprinkled the second and the third shredded paper. After repeated stacking, the result is that the colors are the colors are clearly layered and more interesting and natural.

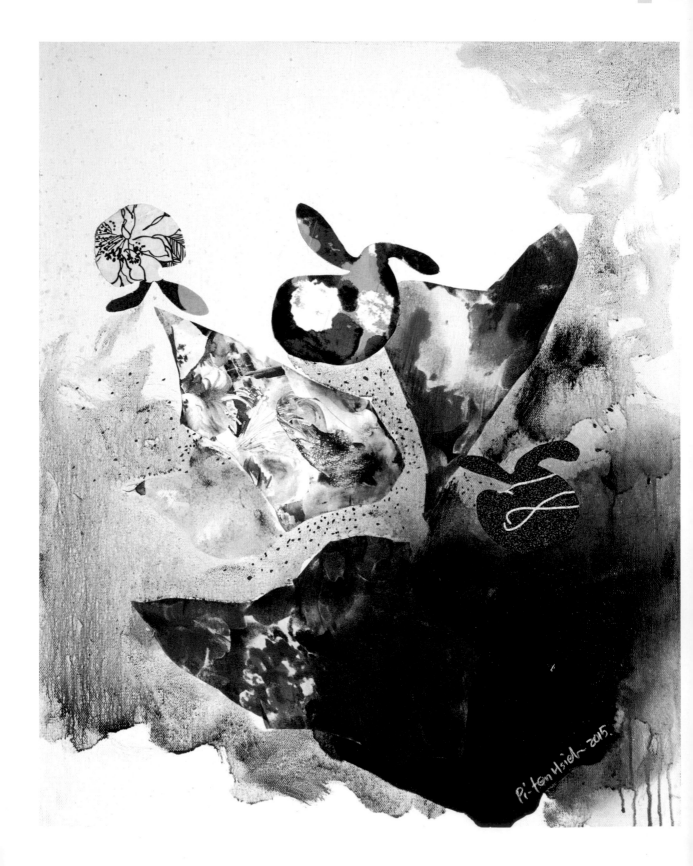

THE SPRING BREEZES IN FEBRUARY

二月春風

2015 20F 72.5x60.5cm　複合媒材

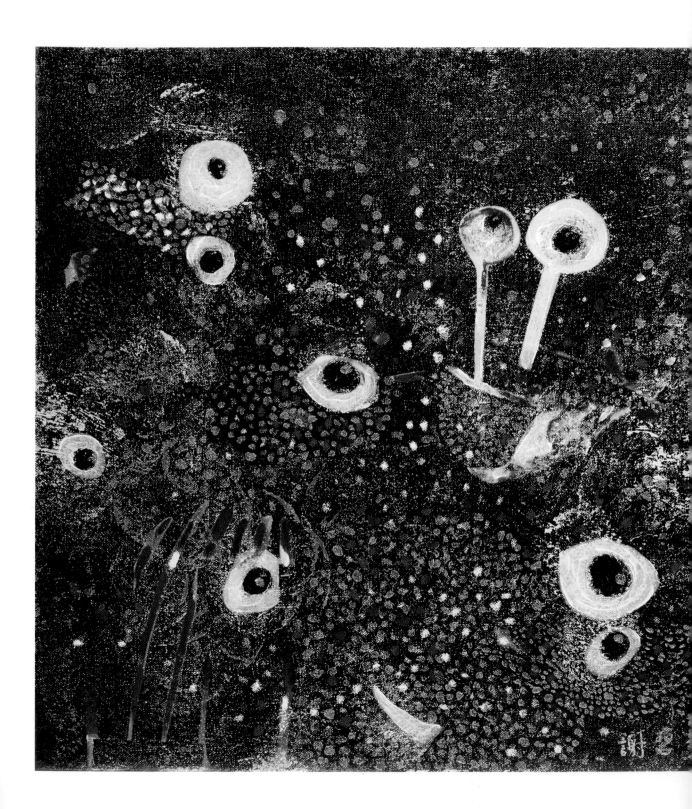

TALKING ABOUT EVERYTHING

談 天 說 地

2022 20F 72.5x60.5cm 複合媒材

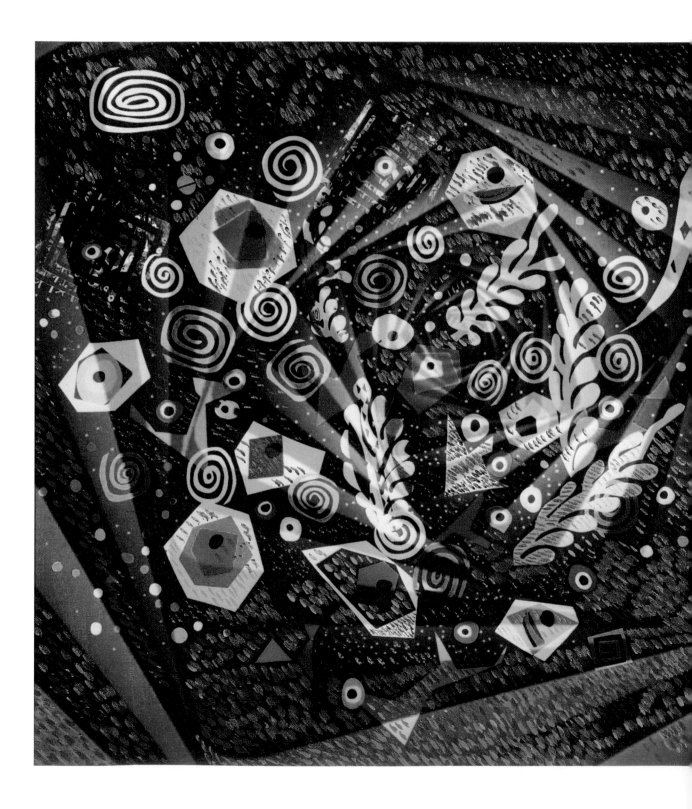

FLOWER SPIRIT

花 精 靈

2021 20F 72.5x60.5cm　複合媒材

TROPICAL RAINFOREST

熱帶雨林

2021　20F 72.5x60.5cm　複合媒材

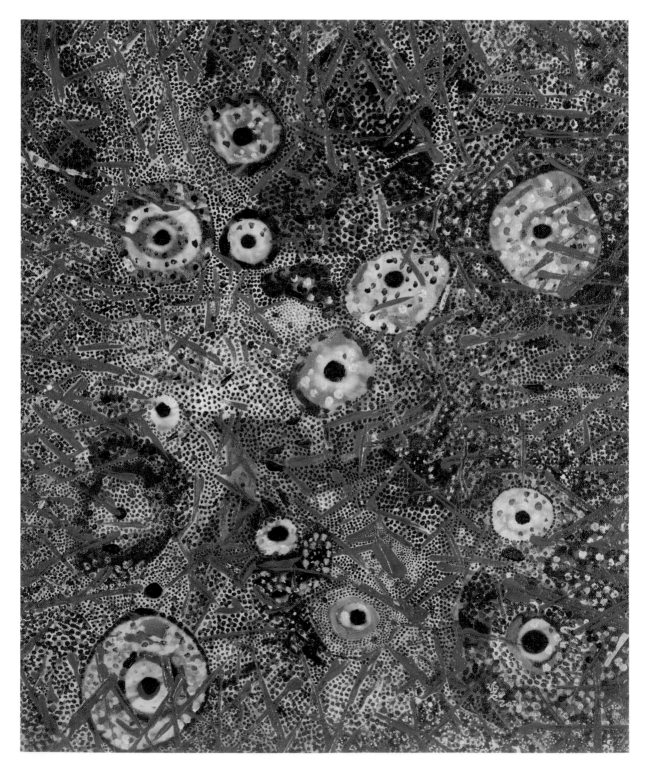

SPRING FEAST

春宴

2011 全開 109.1x78.7cm　複合媒材

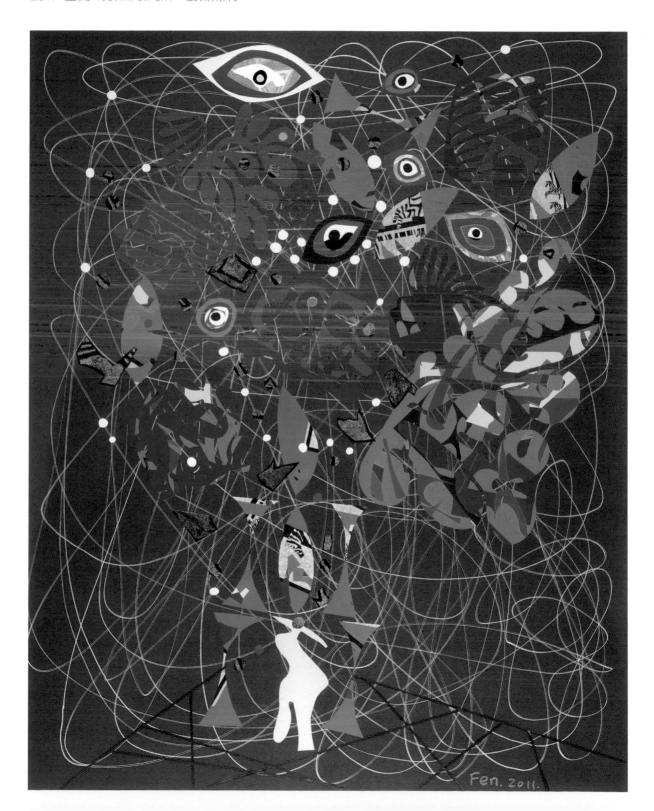

MACRO (I)

宏 觀（一）

2021 20F 72.5x60.5cm　複合媒材

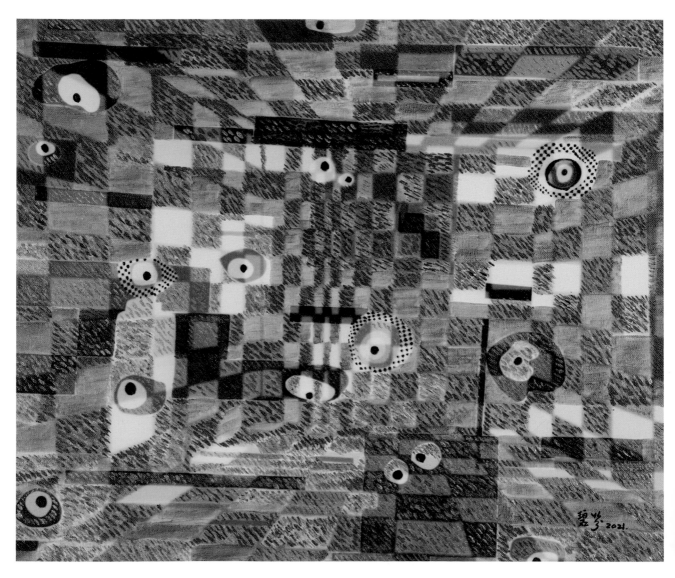

長與方的幾何圖形，加上纖維
布概念，再用點描技法裝飾空
間，好像傳遞聲波的音窗，形
成有幻覺效應的歐普藝術。

MACRO (II)

宏 觀（二）

2022 20F 72.5x60.5cm　複合媒材

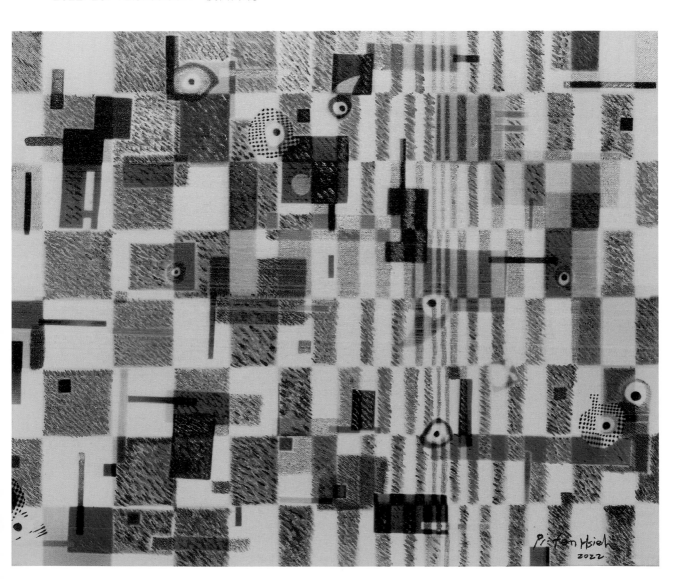

Long and square geometric figures, combined with the concept of fiber cloth, and pointillism techniques are used to decorate the space, like a sound window that transmits sound waves, forming an Op Art with an illusion effect.

SWEET PERSIMMON

柿柿甜蜜

2015 20F 72.5x60.5cm 複合媒材

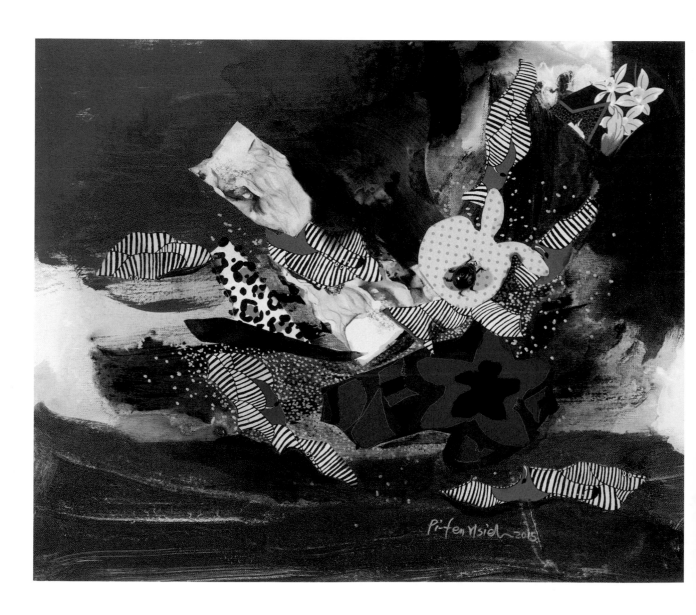

WIND IN THE SKY

風 行 天 上

2015　10F 53x45.5cm　複合媒材

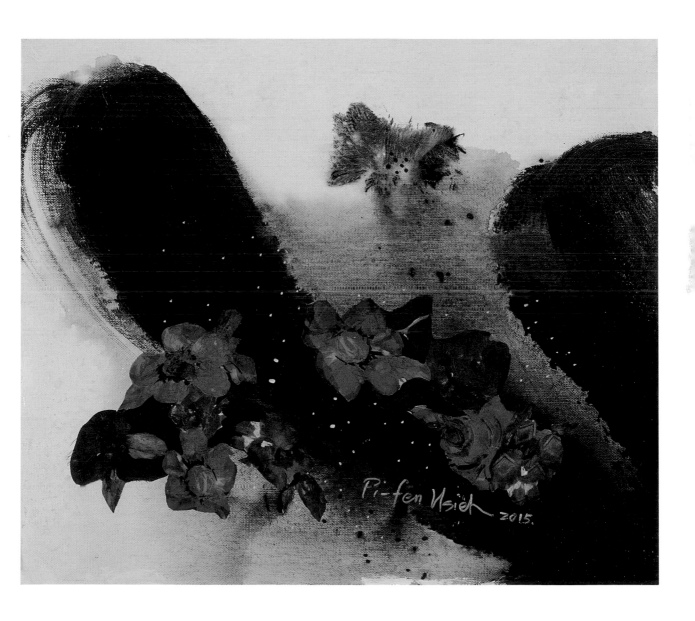

EIGHT AUSPICIOUS

八吉祥

2007 25×15cm 陶盤

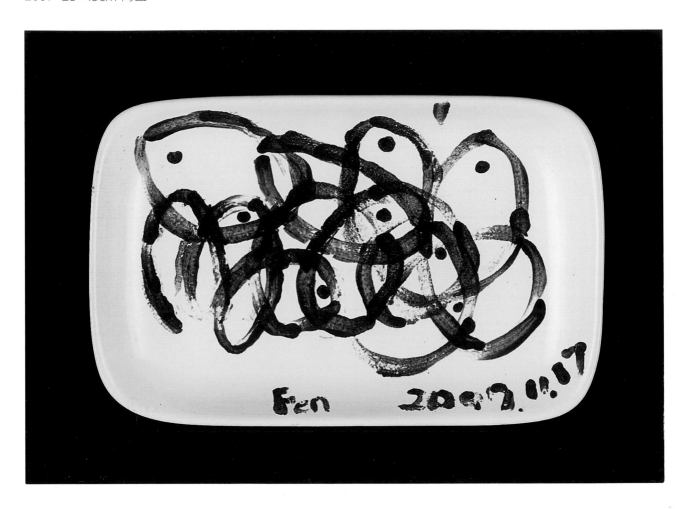

NOCTURNE

夜 曲

2019 30F 91x72.5cm 複合媒材

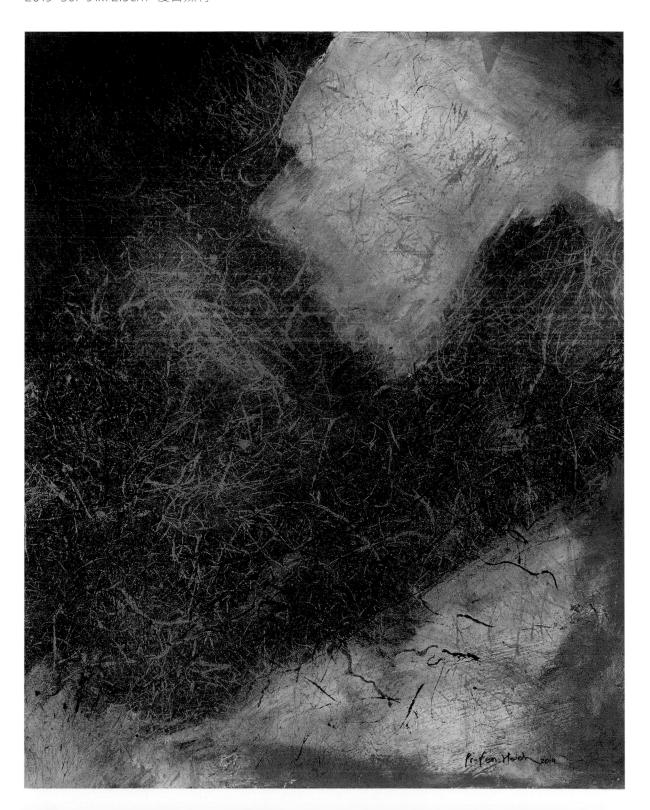

A LIFE OF LIGHT AND DARKNESS

明暗交織的人生

2019　91x72.5cm*4　複合媒材

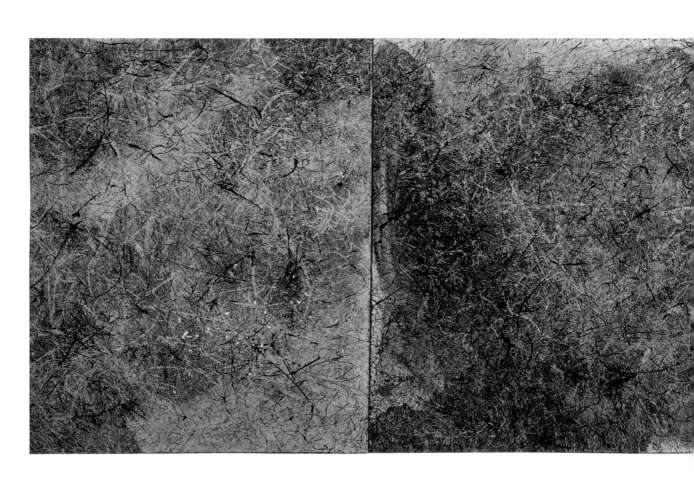

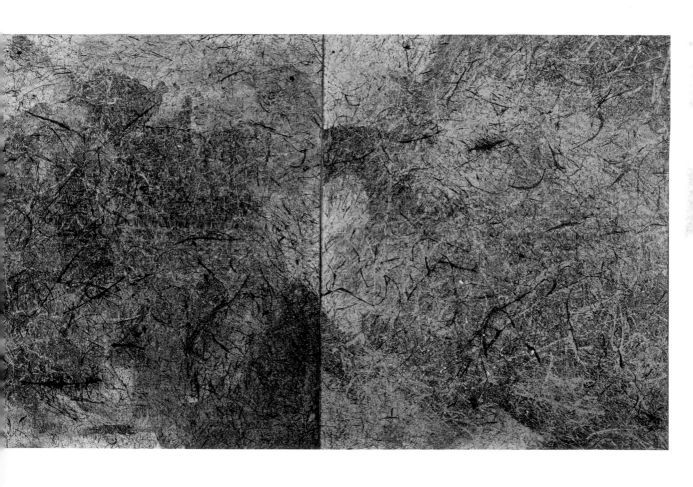

tions

FREEDOM OF MIND

寬心自在

2014 142.5x30cm 複合媒材

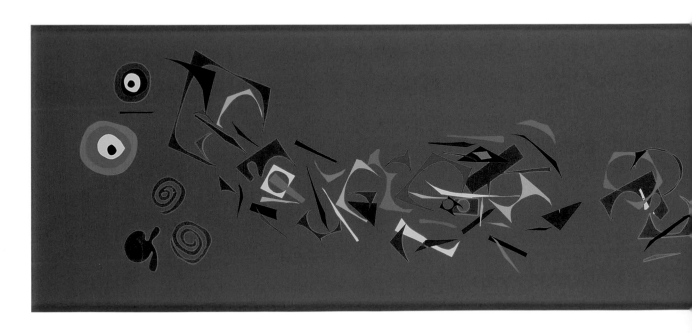

▲ 直幅

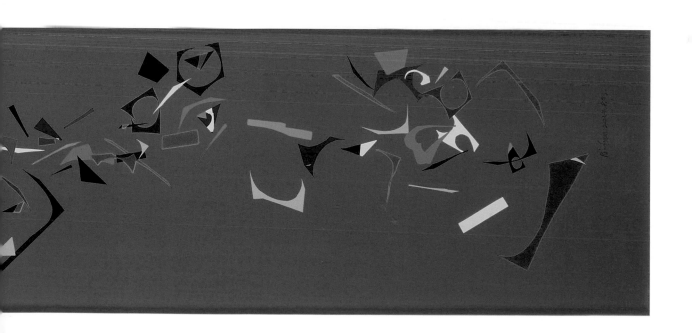

ACQUAINTANCE WITH EACH OTHER

相 生 相 熟

2011 54.5x39.3cm 複合媒材

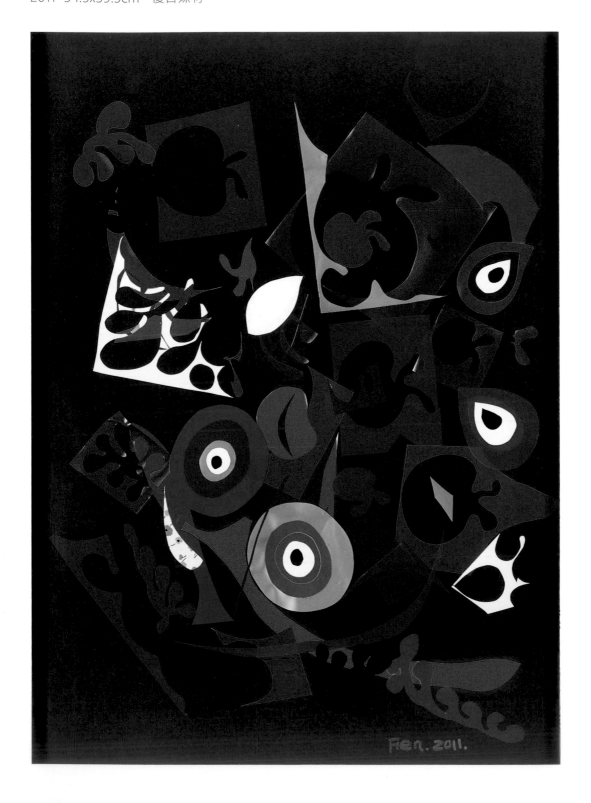

DRUNKEN TANGO

酒 醉 的 探 戈

2010　54.5x39.3cm　複合媒材

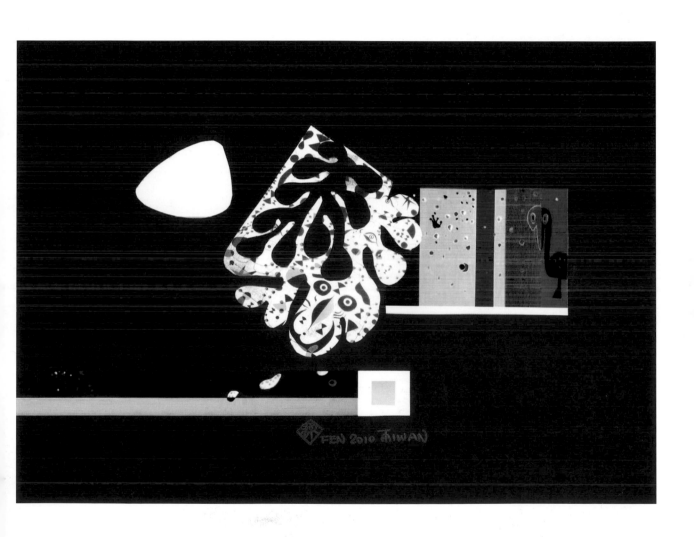

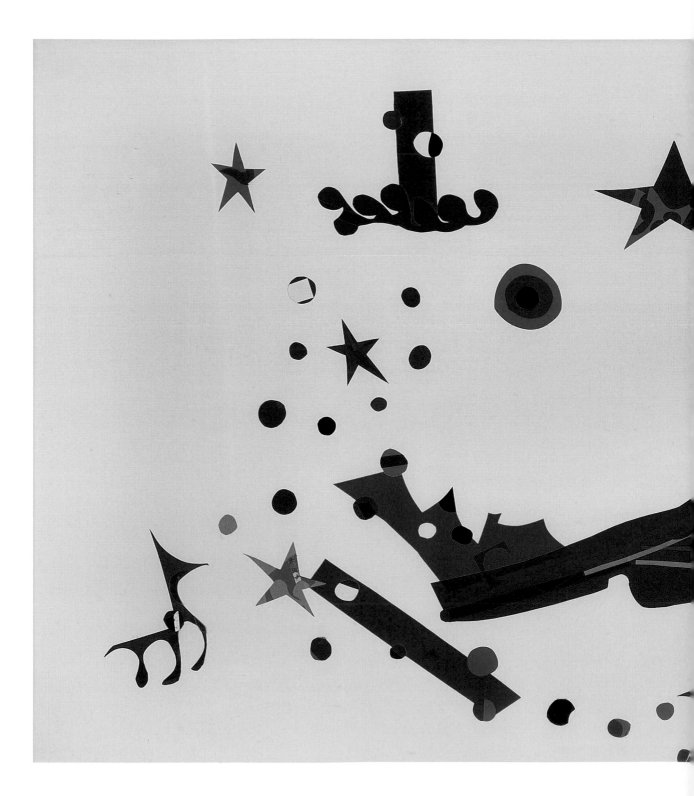

A BIG SHIP ENTERS THE PORT

大 船 入 港

2010　54.5x39.3cm　複合媒材

HAPPY FACE

歡 顏

2014 27.2x39.3cm 複合媒材

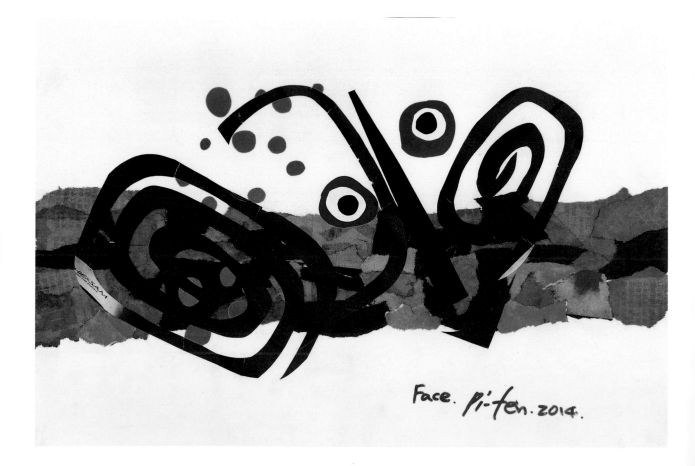

LOVE TÜRKIYE

戀戀土耳其

2012 全開 109.1x78.7cm 複合媒材

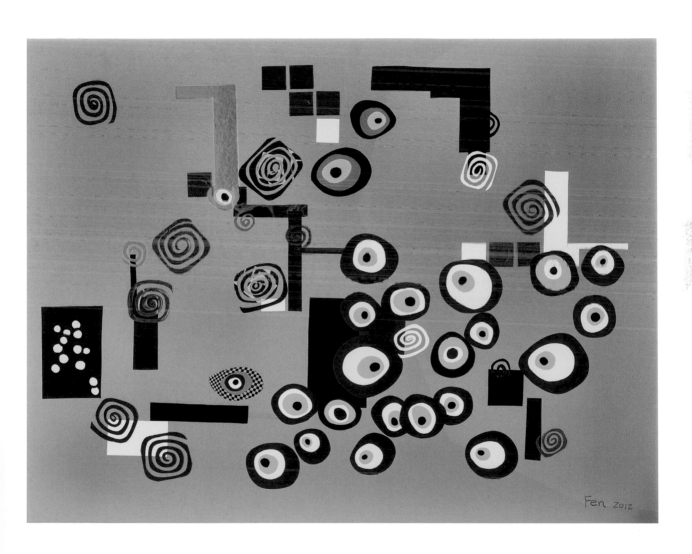

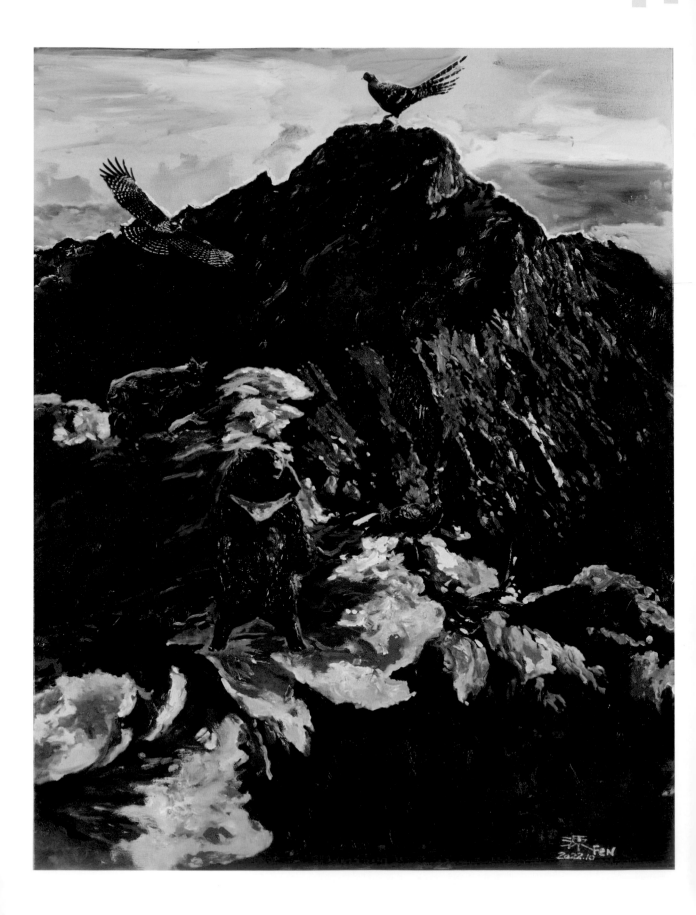

我與先生 2022 年編繪《玉山行旅圖》系列，共有五幅畫作，都是 50F，內心充滿期待，更為台灣祈福。

SPRING / Series of Journey to the Yushan

春　玉山行旅圖系列

2022　50F 116.5x91cm　羅榮源 . 謝碧芬　複合媒材

以帝雉昂首向西望，轟立在玉山頂，做為故事的開始。熊鷹盤旋在空中，長鬃山羊沿著菱線向山頂前進，黑熊、藍腹鷴、藍鵲在雲海中，全神灌注守護台灣。

Begins the story with a Mikado Pheasant standing on the top of the Yushan (Jade Mountain), looking westward, Mountain Hawk-eagle hovers in the sky, Formosan Serow marches to the summit along the ringer line, Formosan Black Bear, Swinhoe's Pheasant, Formosan Blue Magpie in the sea of clouds, fully concentrating on protecting Taiwan.

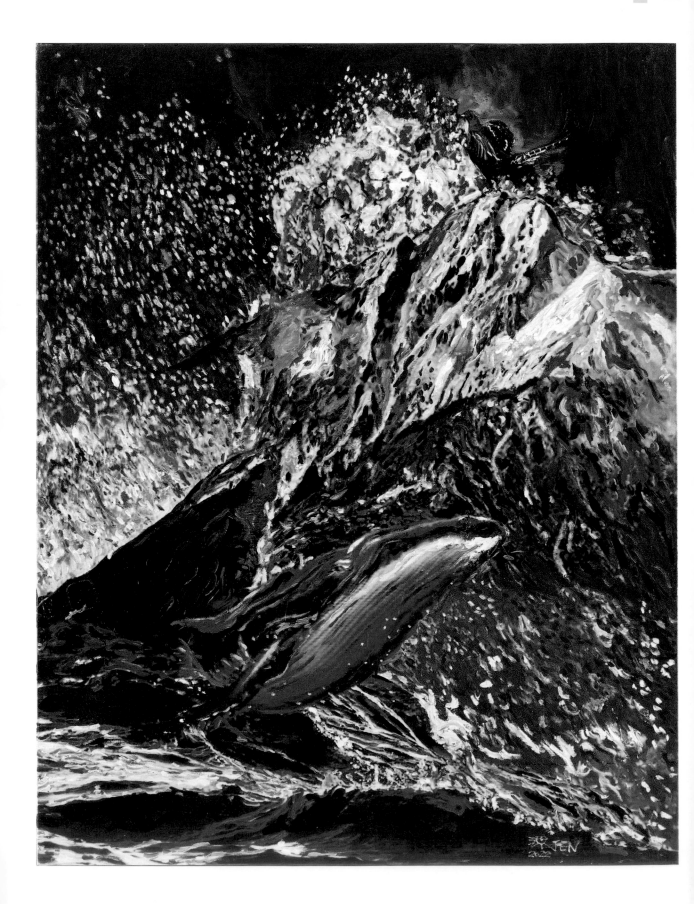

SUMMER / Series of Journey to the Yushan

夏 玉山行旅圖系列

2022 50F 116.5x91cm 羅榮源 . 謝碧芬 複合媒材

波濤洶湧的風雨中，帝雉直立玉山頂，藍鯨衝浪而出，象徵帶領台灣游向世界。

Mikado Pheasant stands on the top of Yushan amidst the stormy waves, and the blue whale rises out of the waves, symbolizing that he is leading Taiwan to swim to the world.

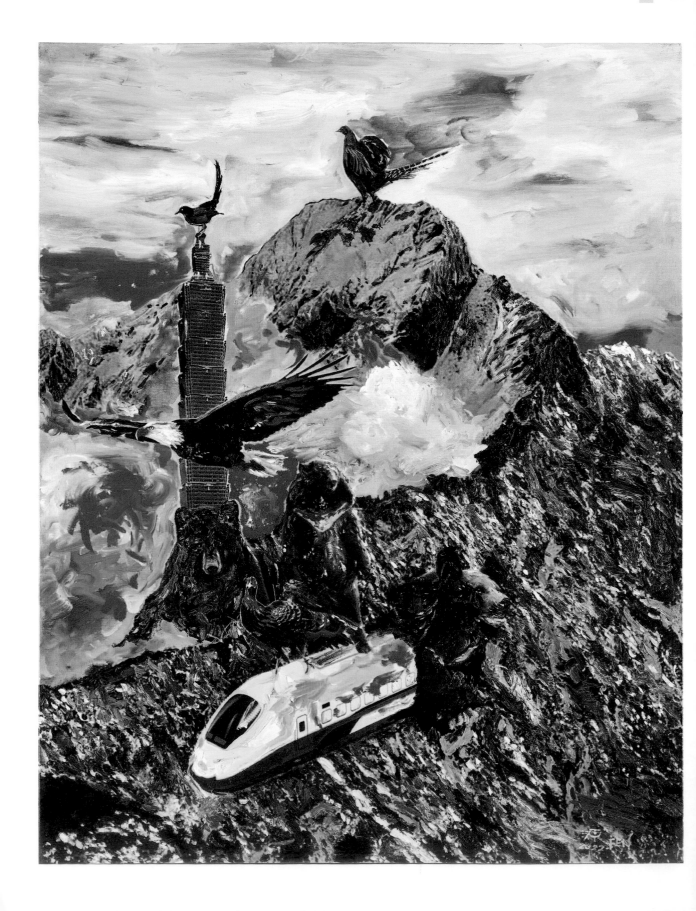

AUTUMN / Series of Journey to the Yushan

秋　玉山行旅圖系列

2022　50F 116.5x91cm　羅榮源 . 謝碧芬　複合媒材

風雨過後，帝雉堅守玉山頂，藍鵲登
上台北 101 大樓，美國國鳥白頭海雕
盤旋台灣上空，黑熊、藍腹鷴搭上高
鐵衝破籓籬，帶領台灣向前衝。

After the storm, Mikado Pheasant holds
on to the Yushan Peak, Formosan Blue
Magpie climbs the Taipei 101 building, bald
eagle hovers over Taiwan, Formosan Black
Bear and Swinhoe's Pheasant take the high
speed train to break through the barriers
and lead Taiwan forward.

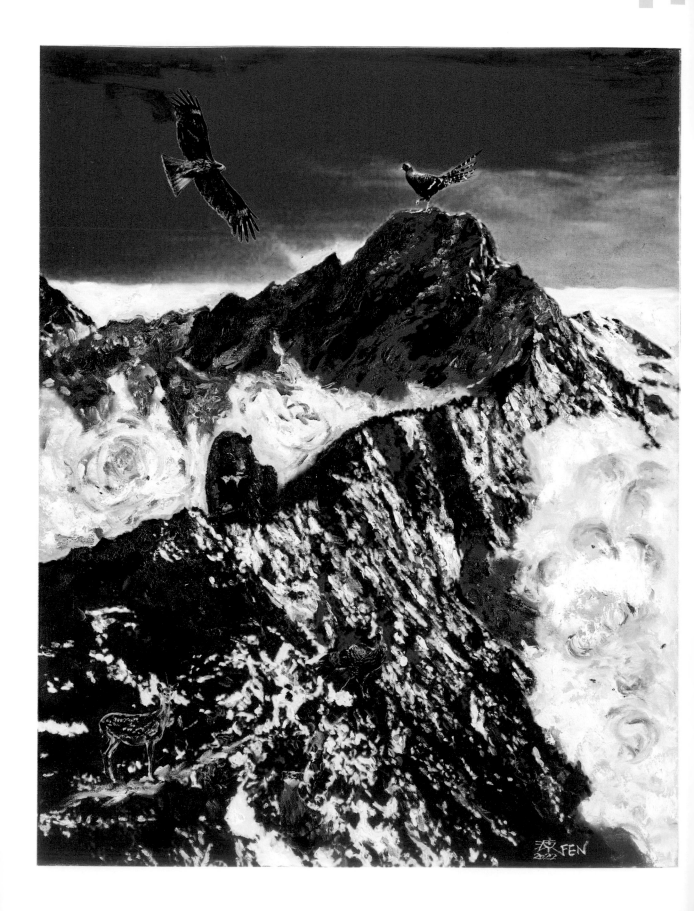

WINTER / Series of Journey to the Yushan

冬　玉山行旅圖系列

2022　50F 116.5x91cm　羅榮源 . 謝碧芬　複合媒材

雲海洶洶環繞玉山，帝雉、熊鷹不畏
急凍，精神抖擻，黑熊、藍腹鷴、梅
花鹿、黃喉貂，為台灣帶來蓬勃生機。

Mikado Pheasant, and Mountain Hawk-
eagle are braving the freezing weather and
are in high spirits as the sea of clouds rage
around Yushan. Formosan Black Bear,
Swinhoe's Pheasant, Formosan Sika Deer,
and Formosan Yellow-throated Marten bring
vitality to Taiwan.

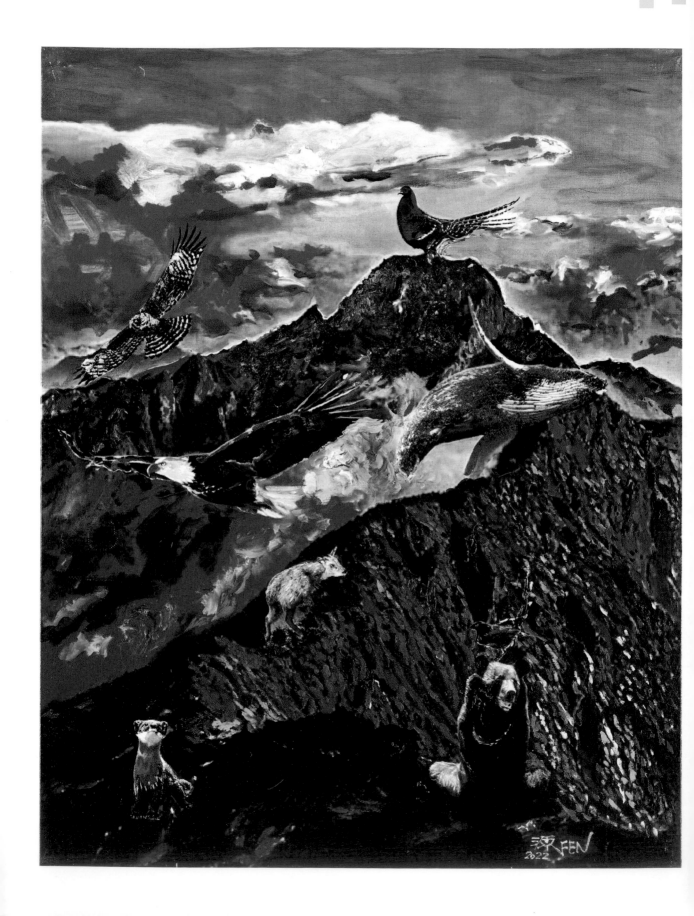

FLOURISHING / Series of Journey to the Yushan

發　玉山行旅圖系列

2022　50F 116.5x91cm　羅榮源 . 謝碧芬　複合媒材

帝雉、熊鷹、白頭海雕、藍鯨、長鬃山羊、藍鵲、黃喉貂、黑熊，以玉山為背景，逐一出場謝幕，為台灣加油。

Mikado Pheasant, Mountain Hawk-eagle, bald eagle, blue whale, Formosan Serow, Formosan Blue Magpie, Formosan Yellow-throated Marten, Formosan Black Bear, with Yushan as the background, come out one by one to thank the curtain and cheer for Taiwan.

國家圖書館出版品預行編目資料

綠概念藝術風台灣 ＝ Green art from Taiwan /
謝碧芬作 . -- 初版 . -- 台北市：前衛出版社，2023.04
面；　公分

ISBN 978-626-7076-98-9(平裝)
1.CST: 藝術 2.CST: 作品集

948.8　　　　　　　　　112005098

Green Art From Taiwan
綠概念藝術風台灣

作　　者　　謝碧芬

英文翻譯　　陳美玲

主　　編　　曾明財

編　　輯　　真納視覺文化 (股) 公司

攝　　影　　古亭河

美術設計　　陳佑昌

出 版 者　　前衛出版社

　　　　　　104056 台北市中山區農安街 153 號 4 樓之 3
　　　　　　電話：02-25865708 ｜ 傳真：02-25863758
　　　　　　官方網站：http://www.avanguard.com.tw

出版總監　　林文欽

法律顧問　　陽光百合律師事務所

總 經 銷　　紅螞蟻圖書有限公司

　　　　　　114066 台北市內湖區舊宗路二段 121 巷 19 號
　　　　　　電話：02-27953656 ｜ 傳真：02-27954100

出版日期　　2023 年 4 月初版一刷

定　　價　　新台幣 500 元

I S B N　　978-626-7076-98-9

* 請上「前衛出版社」臉書專頁按讚，獲得更多書籍、活動資訊

http://www.facebook.com/avanguardTaiwan